IMAGES
of America

NANTUCKET

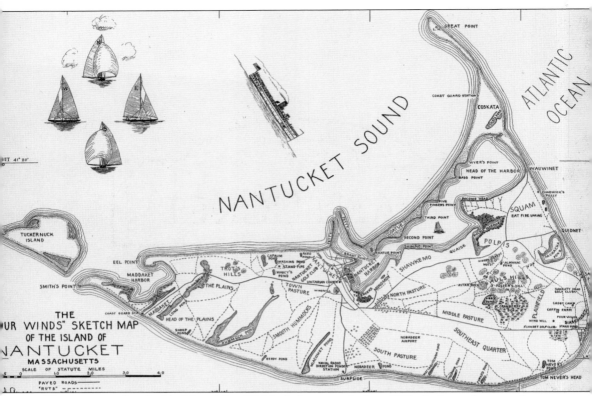

This map was sketched by Vice Adm. W. Mack Angas in the late 1930s. It shows the named areas of Nantucket, paved and rutted roads, prominent landmarks, and the incoming boat. Capaum Pond, on the north shore just west of the town of Nantucket, is where the original settlement was located. (MS1000-RS37, map by W. Mack Angus.)

ON THE COVER: Elisha Pope Fearing Gardner sold peanuts and candy on Main Street in the late 19th century. Main Street was once the home of several food and dry goods stores, as well as the host to other street vendors selling vegetables, fish, and flowers to locals and tourists alike. Today, vendors sell vegetables at the same location. (GPN4097, photographer unknown.)

IMAGES
of America

NANTUCKET

James Everett Grieder and
Georgen Charnes

ARCADIA
PUBLISHING

Published by Arcadia Publishing
Charleston, South Carolina

Printed in the United States of America

Library of Congress Control Number: 2011940546

For all general information, please contact Arcadia Publishing:
Telephone 843-853-2070
Fax 843-853-0044
E-mail sales@arcadiapublishing.com
For customer service and orders:
Toll-Free 1-888-313-2665

Visit us on the Internet at www.arcadiapublishing.com

This book is dedicated to all those who treasure Nantucket's history; to my grandmother Ruth Chapel Grieder, for starting me on this journey; and to three very special Williams.

—James Grieder

For Cassia and Scott.

—Georgen Charnes

CONTENTS

ACKNOWLEDGMENTS

I would like to thank my family for their love and support, Nat Philbrick for his guidance and recommendation, our editor Elizabeth Oldham for her red ink, and my coauthor Georgen Charnes for her patience.

—James Grieder

This book would not be possible without the contributions of the Nantucket Historical Association to the preservation of Nantucket's history. The photograph collections, which have been built with tenacious dedication by staff, volunteers, and community members, are a treasure. The ability to search the collections online is essential in accessing visual historical information. Special thanks goes out to my colleagues Elizabeth Oldham, Ralph Henke, and Ben Simons.

All photographs in this book were made available to us by courtesy of the Nantucket Historical Association and are available for reproduction through the museum store. Thanks go to all the photographers whose work is included here, including Rob Benchley, Cary Hazelgrove, and Charles Folger.

Also, thank you to my husband, Scott Charnes, and daughter Cassia Charnes. This is your heritage we are writing about, and if the book is any good, it is a tribute to you.

—Georgen Charnes

INTRODUCTION

Nantucket is supposedly a rough translation of a Wampanoag word that means "far-away island." According to an ancient legend of that tribe, Nantucket's origins lay in a pair of ill-fitting moccasins worn by a giant named Maushop. Maushop was so big that he could scoop up whales as if they were minnows. One day, as he walked along the shore hunting for his supper, Maushop's feet began to bother him because of sand in his shoes. He took off his left moccasin and poured the sand into the sea, forming the island of Nantucket. The sand from his right moccasin created the island of Noepe, known to us as Martha's Vineyard.

Nantucket's name is somewhat misleading, however, as Nantucket has found itself—both literally and figuratively—in the center of global events time and again. From the earliest days of European contact through the beginning of the 20th century, Nantucket Island was in the middle of an aquatic superhighway of sorts, as first sail, and then steam-driven vessels plied their trade up and down the East Coast and across the Atlantic. Those ships brought not only goods and passengers, but also ideas, some of which took root in the fertile soil of Nantucket Quakerism's radical egalitarianism. Those ideas, nurtured on Nantucket's shores, were in turn returned to America, oftentimes to a hostile reception.

Native-born abolitionists Lucretia Coffin Mott (1793–1880) and Phebe Coffin Hanaford (1829–1921) were raised in this environment, as was astronomer and scholar Maria Mitchell (1818–1889), whose legacy of inquiry is carried on to this day by the organization that bears her name. Frederick Douglass (1818–1895) gave his first public address to a mixed-race audience on Nantucket, and other freethinking luminaries like Henry David Thoreau (1817–1862) and Ralph Waldo Emerson (1803–1882) found ready audiences here. Educational pioneers Horace Mann (1796–1859) and Cyrus Peirce (1790–1860) discovered that the habits and ideals of the island community reflected their own vision of the future of public education. These values did not come easily, however; they were forged by the precarious nature of island life, where one is forced daily to acknowledge humanity's mortal status and equal standing before the might of the ocean's tides and storms. When Benjamin Franklin, son of Nantucket-born Abiah Folger, told his fellow signers of the Declaration of Independence that they must all hang together or, assuredly, they would all hang separately, perhaps he was echoing a sentiment that he learned from his mother.

The island of Nantucket, when first settled by Europeans, was occupied by some 3,000 Wampanoag men, women, and children. In 1641, Thomas Mayhew purchased Martha's Vineyard and Nantucket from Sir Ferdinando Gorges and the Earl of Sterling through the earl's agent James Fawcett. In 1659, he sold Nantucket to Tristram Coffin and his fellow proprietors: Peter Coffin, Thomas Macy, Christopher Hussey, Richard Swain, Thomas Barnard, Stephen Greenleafe, John Swain, and William Pike. As the story goes, Mayhew asked for "thirty pounds sterling and two beaver hats, one for me and one for my wife" for Nantucket on July 2, 1659. The partners also later sought and received additional deeds for their new lands from the local sachems. The original purchasers agreed to have 10 other partners, "who should each have half as much land as themselves, called for that reason 'half share men.' " These were to be "planters" and were required to move to the colony within a specified time and practice a needed trade or else forfeit their half share.

In October 1659, a small advance party set out for Nantucket from Salisbury, Massachusetts, on the Merrimack River. Two years later, Tristram Coffin moved to Nantucket with his wife, mother, and four of his children. Some of Coffin's fellow full-share proprietors joined him in making a home on the island, but others did not, looking at their interest in the joint-stock venture as an investment rather than a dream fulfilled. It is in part the latter arrangement that would later cause no small amount of controversy in the community: absentee proprietors and full-share men on the one side, led by Tristram Coffin, and a number of disaffected half-share planters and laborers on the other, who had no control over how their community was governed. All that they lacked was a focus for their discontent, and within five years of Tristram Coffin's arrival on the island, they found it in the form of a fisherman named John Gardner.

In 1666, Richard Gardner arrived on Nantucket to ply his trade; in 1672, his brother John was offered a half-share in return for relocating to Nantucket to do the same. The Gardners purchased much of the land adjacent to and surrounding the Lily Pond, extending beyond Gardner's Burial Ground, across through "Egypt" (the land between North Liberty and Lily Streets) to much of today's Main Street. The Gardner brothers, with an eye for expanding trade and fishing interests, had planned their purchases around the Great Harbor at Wesko, where today's downtown is, and along West Chester Street, the oldest street on the island, that ran from the old settlement at Capaum to the Gardners' new wharves. Over time, the center of the town shifted: by 1711, a house of worship, perhaps Presbyterian or Baptist, was located near the north head of Hummock Pond, and within 20 years, a large Quaker Meeting House was built at the corner of today's Quaker and Madaket Roads (now the Quaker Cemetery). The first town house and town gaol were erected on a small rise, or hummock, north of No Bottom Pond, and they were eventually relocated farther east at Monument Square and on Vestal Street, respectively. Meanwhile, the Presbyterians had erected their own structure called the North Shore Meeting House, located at the south end of Capaum Pond. This structure was later disassembled and moved to Beacon Hill in 1765 and built where the current Congregational church is located today; it was shifted to its current location in 1834, when the larger church was built.

Long-simmering tensions between the half-share and full-share owners eventually boiled over, and open conflict arose between the half-share men, led by the Gardners, and the full-share proprietors over political control of the colony. The initial venture was a joint-stock company, an early form of a corporation, and Tristram Coffin and his fellow full-share proprietors—the board of directors, as it were—sought to control it as a private enterprise. Coffin may have been inspired by Thomas Mayhew, from whom he bought Nantucket and whose settlement on Martha's Vineyard was chartered as a manor, independent of any other form of control except the Crown itself. Whether he saw himself in such a lofty state of affairs or not, he had no interest in sharing control of the venture with the half-share "washashores," as people from off-island are called.

This latter group, the stockholders, was powerless to control the direction of the colony in a system that was rigged against them, although they controlled town meetings under the leadership of John Gardner. It was only when outside circumstances changed that opportunities arose to realign the social order; a series of short-term wars between Holland and England and the restoration of the monarchy in the mother country provided fertile ground for long-nursed grievances to be addressed and the resulting backlash to take place.

The immediate cause of the conflict was the struggle concerning private control by a few over a community pitted against a deeply ingrained Yankee sense of egalitarianism and communal consensus, no doubt enhanced by the formidable personalities of both Tristram Coffin and John Gardner. But there was also a larger, more amorphous struggle as well between two visions of the world: one inward, insular, and with an eye toward sheep herding and farming; the other outward, expansive, and looking to the sea for its fortune. The two sides eventually reconciled, and in 1686, Jethro Coffin, son of Peter Coffin and Abigail Starbuck and grandson of Tristram Coffin and Edward Starbuck, married John Gardner's daughter Mary. John Gardner gave them a parcel of land on Sunset Hill, and they built a house there with lumber supplied by Peter Coffin. To this day, there stands a house called the Oldest House, although it is much altered from its

original form. The Oldest House was in its design unique, however, and is larger than most houses of the period; it does not provide a sense of the size and design of the typical Nantucket dwelling at that time. For that, one must turn to the Richard Gardner II house at 139 Main Street (which is of the period and retains the scale but has been extensively renovated) and several smaller cottages in Siasconset, or 'Sconset.

Early efforts at whaling took place close to shore, emulating the type of whaling that the local Wampanoag had been pursuing for some time. Towers were constructed, and when whales were spotted, boats were rowed out to hunt the whales. Whaling stations were built at Cisco, Miacomet/Surfside, 'Sconset, Sesachacha, Peedee (between the two larger settlements), and Coskata. Collections of shacks were built around these stations, most of which disappeared when whaling shifted offshore. For a while, Sesachacha was the second largest English settlement, boasting 30 or so cottages by 1676. A few houses remained there through the late 19th century, but many of the cottages were relocated to 'Sconset, and some of which remain to this day, representing one of the only collections of domestic medieval architecture in North America. Their layout and construction are very similar to earlier and contemporary structures found in the United Kingdom, which makes a good deal of sense; once the English arrived on these shores, they duplicated the type of dwelling that had served both them and their forebears well over the preceding centuries. During the following decades, these simple houses evolved into the typical Nantucket house that we know today.

It wasn't too long before Nantucket whaleships began hunting farther afield for their quarry, expanding into the Pacific Ocean on voyages that often lasted for years, if they even returned at all. Given the precarious nature of their husbands' livelihoods and island life in general and left to shift for themselves, Nantucket women assumed an independent role that was unusual in the 19th century; it was fostered by the island's predominant Quaker faith, which valued simplicity and thrift and saw men and women as equals. These traits were the seeds for a radical egalitarianism that would soon place Nantucket in the vanguard of national and international social reform movements.

Quakerism weakened as the island's wealth grew, not as a direct result of the changes in fortune, but partly due to the new ideas and opportunities that arrived on the island. Quaker meetings attempted to clamp down on the behavior of its members but only succeeded in driving increasing numbers of them away from the faith. Modest Nantucket homes gave way to mansions for the well-to-do Nantucketer, many of which still line the main streets of the island. The great fire of 1846, which gutted downtown Nantucket, the call of Civil War, and the discovery of petroleum and gold on the mainland crippled the island's economy, and many people left to seek their fortunes elsewhere. Those who remained continued to eke out a living through commercial fishing and farming. Attempts were made to establish other industries—a silk factory and a straw hat factory—but those ventures failed to reinvigorate the economy.

Toward the end of the 19th century, Nantucket began to attract tourists from the mainland who valued its setting and scenic beauty, but vacationing here was by no means an off-island invention; as 'Sconseters upgraded and transformed their crude fishing shacks into snug cottages, Nantucketers pioneered vacationing in the village at the eastern end of the island and continued to do so for two centuries before the first off-island tourists arrived. A summer colony of artists was established in 'Sconset just before the turn of the 20th century, and in the early 1920s, another colony of waterfront artists helped to reinvigorate the downtown of Nantucket proper. During the last 100 years, the trickle of visitors to the island has become a flood, even as the traditional livelihoods like commercial fishing have declined. The later part of the last century witnessed explosive growth in the building trades and real estate as the year-round population attained a level last seen at the height of the whaling era.

Nantucket Island, a mere sandbar in the ocean, a spit of land at the mercy of wind and tides, has had an impact on the world that far outstrips its diminutive size. From lighting the lamps of the world to enlightening the minds of its citizens, Nantucketers have been integral in the creation of the world that we live in today. Now, once again, the island acts as a harbinger of future changes:

erosion of its land is exacerbated by global warming, and pollution of its waters is accelerated as the population grows and demands on the environment increase. These are challenges that all of humanity faces, but if past success is any indicator of future accomplishment, then perhaps it is on this fragile outpost in the sea that some of the best ideas for our common future will be born.

One

THIRTY POUNDS AND TWO BEAVER HATS

The island of Nantucket, when first settled by Europeans, was inhabited by two factions of the Wampanoag tribe, occupying the north and south halves, respectively. The two groups were, at times, hostile to each other as they competed for the island's scarce resources. The population of both clans is unknown and may have swelled considerably as mainland Wampanoag came to the island, seeking refuge from disease and warfare, but the generally-recognized figure is around 3,000 in all.

When the English arrived, they put further strain on an already over-taxed island: their sheep roamed the island, eating the plants and grass, and their farms eroded the thin topsoil. They built mills on the island's few slow-moving creeks in an effort to harness their energy for the processing of wool, but it was the windmill that best suited the island's windswept landscape.

As the number of English lean-to houses grew and the scarce resources diminished, the demand for more land increased. During the next 100 years, many transfers of property from the Indians to the English are recorded, typically by one tribe selling land belonging to the other. By 1774, virtually the entire island had been sold to the "washashores," in part because there were very few Wampanoag left; in 1763, the local population suffered from an epidemic that ravaged the community. When it ended in February 1764, of the 358 Indians on the island, 222 had perished.

By 1791, only four male and 16 female Wampanoag were left on the island; by 1809, there remained only three or four persons of "pure blood" and a few of mixed race. Sarah Tashama, daughter of Benjamin Tashama, the last sachem of Nantucket, gave birth to a daughter in 1776. She was named Dorcas Honorable, and she died in 1822. Abram Quary, of mixed parentage, lived in a hut at Shimmo for many years and died in 1855 at the age of 83. His portrait can be seen in the Nantucket Atheneum.

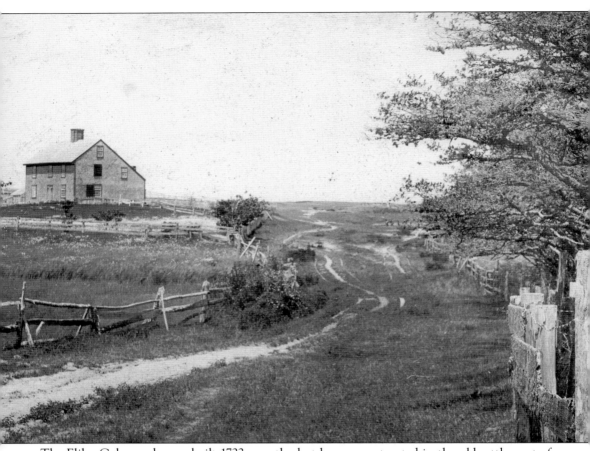

The Elihu Coleman house, built 1722, was the last house constructed in the old settlement of Sherburne, which centered around Capaum Pond. The town had already begun to move to the east when this house was being constructed. It shows the lean-to, or saltbox-style, characteristic of the 18th century. The style is noted for having two stories in front, one in back, and a roof with a steep pitch. Houses faced south, even after many were moved, board by board, to the new town location. Nantucket has over 800 houses that were built before the 1860s. The Elihu Coleman house is double in size and still standing on Hawthorne Lane. The introduction of the newer style of house was often resisted by the older generation; legend has it that Richard Macy refused to enter the house of his son Job Macy at 11 Mill Street because it was not a lean-to. (A53-37, photograph by Henry S. Wyer.)

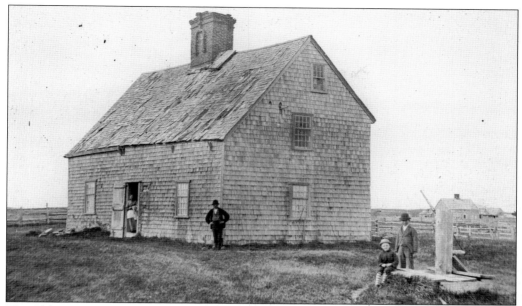

The Oldest House, still standing on Sunset Hill, was built in 1686 as a wedding present and also as a peace offering in a feud between the proprietors and the half-share men. The house, acquired by the Nantucket Historical Association in 1923, and its historical garden are open to the public. (P6422, photograph by Charles H. Shute & Son.)

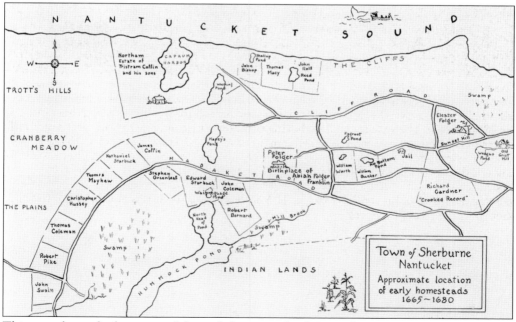

This map shows the locations of the early homesteads of Nantucket's first settlers from 1665 to 1680. Capaum Harbor was the center of Sherburne until storms closed the harbor in the 18th century. All of the roads on this map are still in used in present-day Nantucket. Many of the homes from Sherburne were moved board by board to new locations when the town moved east. (MS1000-1-1-10, photographer unknown.)

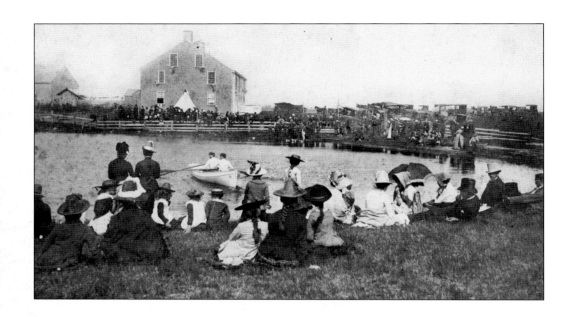

The original 20 proprietors of Nantucket were allotted one share each of the sheep commons, and 14 others were owners of half shares. This determined the number of sheep each shareholder was allowed to graze on the sheep commons, which was a large portion of the center of the island. Starting in at least 1676, the Monday nearest June 20 was the day of the annual sheepshearing festival. Sails were spread over pens for shade while men sheared the sheep. Onlookers feasted and socialized, and later, a dance was held. These photographs show sheepshearing parties at Quaise Farm, owned by Harrison Gardner. (Above, SC670-53, photograph by Henry S. Wyer; below, GPN4311, photographer unknown.)

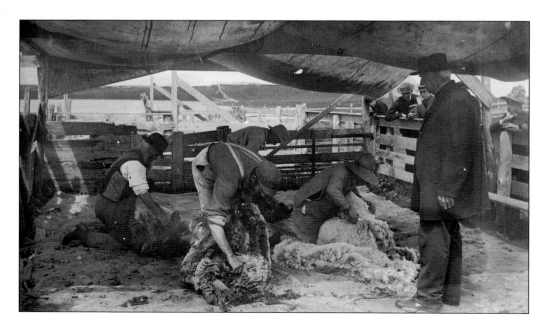

Nantucket once had a group of four smock mills in a row. Smock mills have a fixed body with a top that can be turned to face into the wind. Only the easternmost mill of the four is still standing. It was built in 1746 by Nathan Wilbur. In 1828, it was sold to Jared Gardner in poor condition, "for firewood." Gardner, apparently a talented carpenter, repaired the mill to grind corn again. In 1866, it changed hands again, this time bought by John Francis Sylvia, a miller of Azorean descent. He operated the mill with Peter Hoy for many years. After being unused for several years, it was purchased in 1897 by Caroline French for $850 and donated to the Nantucket Historical Association. The mill still grinds corn during the summer. (GPN3186, photograph by Henry S. Wyer.)

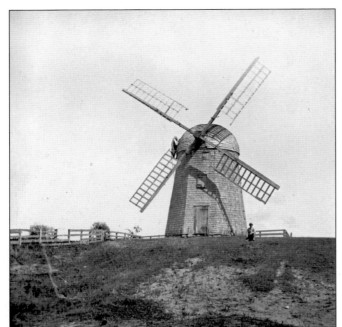

The Round-Top Mill, built in 1802, was Nantucket's fifth mill. It stood near the intersection of New Lane and Franklin Street. When it was demolished in 1874, its millstone was used as a foundation for the Civil War monument at Main and Milk Streets. (GPN2893, photograph by Josiah Freeman.)

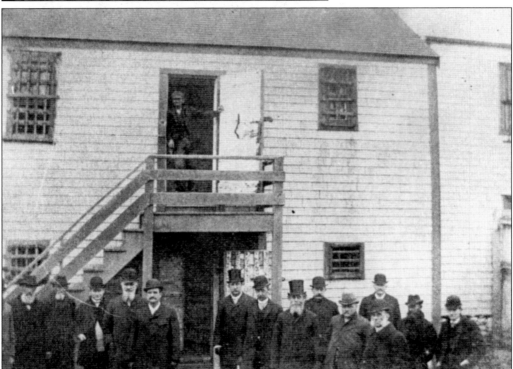

In 1677, Peter Folger, an Indian interpreter and town clerk, was incarcerated in an earlier jail for refusing to turn over the town records to the town constable. The first jail was built in 1696. In 1806, this new building was constructed; the town of Nantucket deeded it to the Nantucket Historical Association in 1933. (P7150, photographer unknown.)

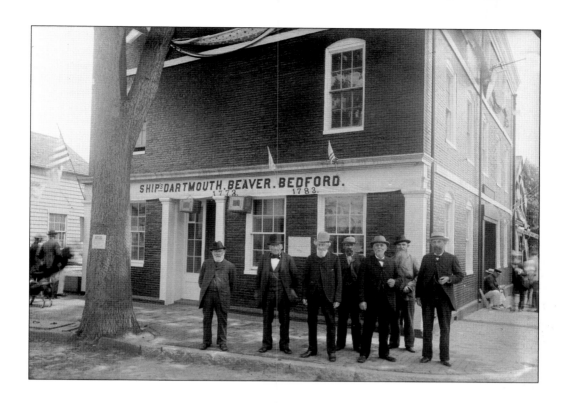

The brick building at the bottom of Main Street Square was originally constructed in 1772 as a countinghouse by William Rotch, a wealthy whaleship owner and staunch Quaker. Two of the ships Rotch owned, the *Dartmouth* and the *Beaver*, were involved in the Boston Tea Party of 1773, with colonialists seizing tea from the ships to dump in the harbor. Rotch, like many Nantucketers, wanted the island to remain neutral in the American Revolution, not just because of the pacifism of the Quaker religion, but also because their livelihoods depended on good trading relations with England. One of Rotch's other ships, the *Bedford*, was the first to fly the Stars and Stripes, the flag of the new United States, in a British port in 1783. The Pacific Club was established in 1854 by a group of 24 whaling captains as a meeting place. The 1895 photograph above shows several retired sea captains, unfortunately unidentified. (Above, GPN4478, photograph by Henry S. Wyer; below, F3019A, photographer unknown.)

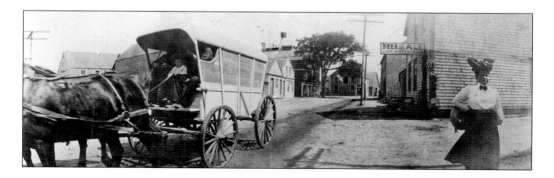

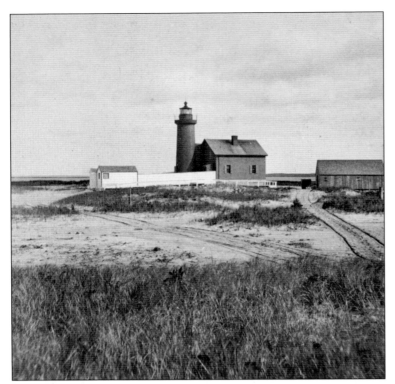

The first lighthouse on Brant Point was a basic structure of platforms and lanterns. It was built in 1746 and destroyed by fire in 1758. This photograph shows the eighth Brant Point lighthouse, built in 1856 with an attached house for the keeper's family. (P6409, photograph by Josiah Freeman.)

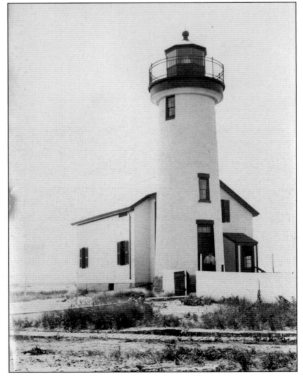

The eighth Brant Point lighthouse and the keeper's house was painted white around 1895. Because of shifts in the channel, the lighthouse was discontinued in 1900; for a short time, it was replaced with a fixed red light on a pole before the new lighthouse was built. (P11713, photographer unknown.)

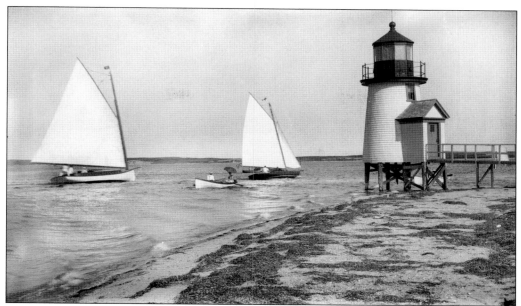

In 1900, a new Brant Point lighthouse was built at the end of the point. The old light still stands at the Coast Guard station. The lantern top of the old tower was moved to the new site, and the old tower was capped. The beam is 26 feet above the water, making it the lowest lighthouse in New England. The riprap was added in 1902. (GPN4297, photographer unknown.)

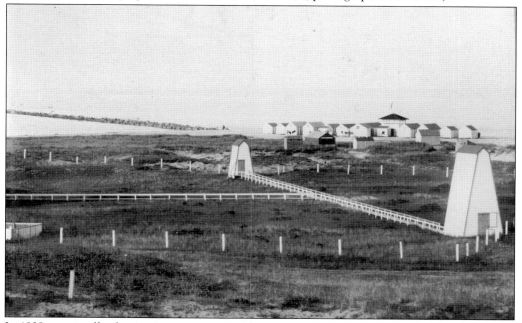

In 1839, two small, white towers were constructed near Jetties Beach below the cliff. These "bug-lights" assisted mariners in entering the harbor safely by lining up the lights. This image shows the bug-lights after they were reconstructed in 1889. After they were retired in 1908, they were purchased and moved by author Frank Gilbreth and used as dormitories by his children. (A53-16, photograph by Henry S. Wyer.)

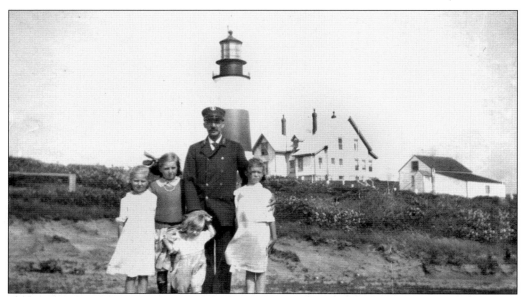

Sankaty Light was built in the winter of 1849–1850. Keeper Eugene Larsen was the assistant keeper from 1914 to 1918 and the keeper from 1918 to 1944. He and his wife, Edvardine, arrived with two daughters and had five more during their time in the lighthouse. (SC356, photographer unknown.)

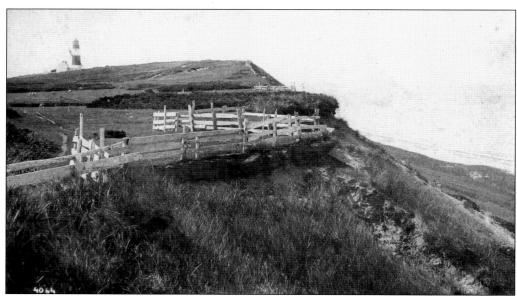

After erosion caused the lighthouse to be in danger of falling over the bluff, a local nonprofit organization, the 'Sconset Trust, raised funds and had the lighthouse moved away from the edge. In October 2007, the 450-ton lighthouse was placed on rails and moved 405 feet inland. (F4965, photograph by Baldwin Coolidge.)

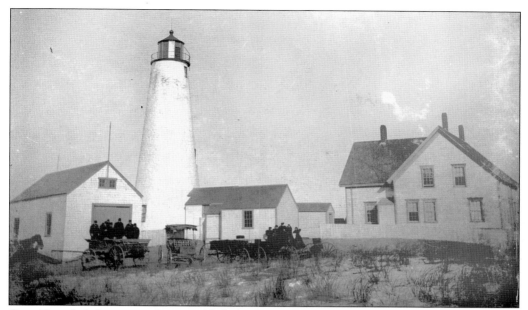

Great Point lighthouse was the second light built on Nantucket. The original building, constructed in 1785, burned down in 1816, and the familiar white round tower was erected two years later. Frank A. Grieder, great-grandfather of author James Grieder, was keeper between 1935 and 1937. Keepers' homes were adjacent to the lighthouse and typically very isolated. Often, families would send their children to board in town for school. (GPN4570, photographer unknown.)

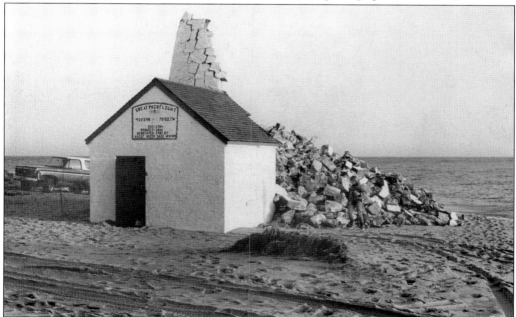

The lighthouse was automated in the 1950s. In March 1984, the 1818 lighthouse was destroyed in a storm. A replica was built in 1986. Today, solar panels are used to recharge the light's batteries. Great Point light's old Fresnel lens is on display outside the Nantucket Lifesaving Museum. (P21631, photograph by H. Flint Ranney.)

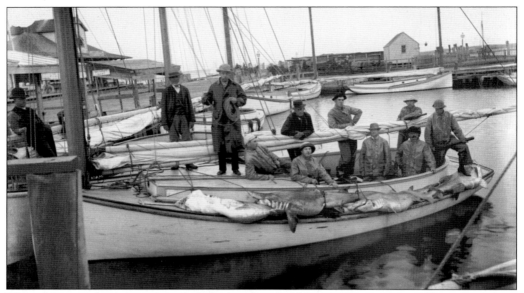

These fishermen have several sharks lashed to the side of their catboat in Adams Slip at Steamboat Wharf. Many catboats were available for hire at Adams Slip. One can still see this style of boat in the harbor, now used recreationally. In the background is the Ladies and Gents Restaurant. (GPN3150, photographer unknown.)

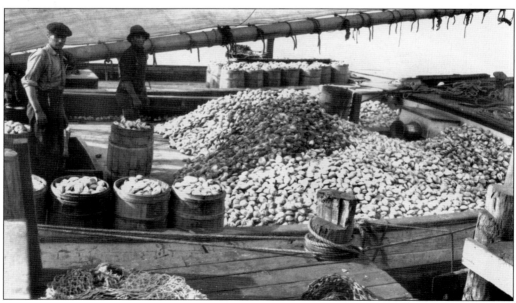

Without limits imposed, fishermen filled their boats with as many clams as they could take. This photograph shows two men off-loading their haul. Two years after a huge bed of quahogs was discovered north of the jetties in 1913, a Nantucket fish-packing company set a record of 1,426 fish exported to the mainland. (F6442, photographer unknown.)

Pilot whales, or blackfish, strand themselves on Nantucket beaches periodically. Native Americans and, later, the settlers also drove the animals onto the beach to be butchered. Often, the meat was dried and made into jerky. This photograph was probably taken during the 1874 stranding. (PH73-15, photograph by Josiah Freeman.)

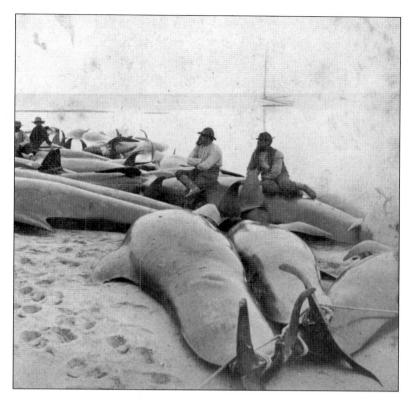

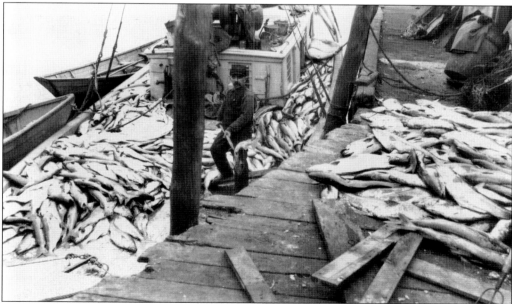

James Everett Smith is shown here unloading a catch of pollock from the *Petrel* in June 1915. The vessel lent its name to Petrel's Landing, a grassy area near Commercial Wharf. Born on Tuckernuck, Smith was the son of James Guerney Smith and Susan Dunham Smith and lived at 8 Union Street. (F6438, photographer unknown.)

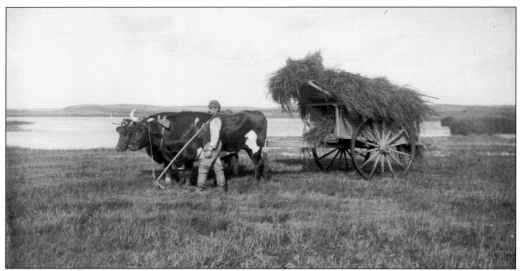

Salt hay was harvested from several open areas on the island and used for animal bedding; later, it was worked into the soil with manure. This photograph features Charles Raymond salt haying with his oxen-drawn cart at Joe Folger's meadow in Quaise, near Polpis Harbor. (GPN2774, photograph by Henry S. Wyer.)

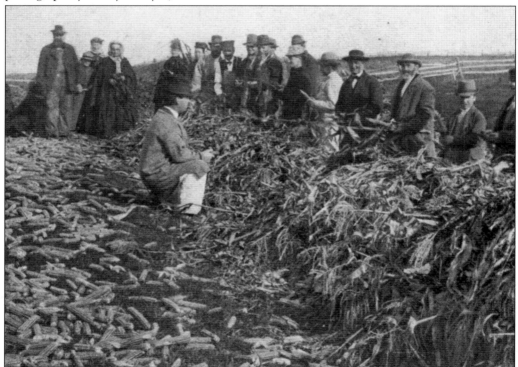

Husking parties were part of the traditional cycle of agrarian Nantucket. This photograph shows people husking corn at Rosewood Farm. Typically, this kind of event is used as an excuse for a party and involved sharing a meal, dancing, and a contest to find the red ear of corn. (P6556, photograph by Josiah Freeman.)

In the 1850s, there were over 150 farms on Nantucket. According to Will Gardner in his article "Nantucket Farms" (*Proceedings of the Nantucket Historical Association*, 1947), Obed Swain left to go whaling and found his wife had made more money farming than he had whaling. This photograph shows pumpkins and the farmhouse at Pine Grove Farm. (GPN440, photographer unknown.)

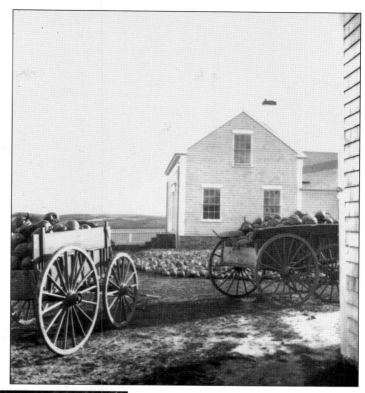

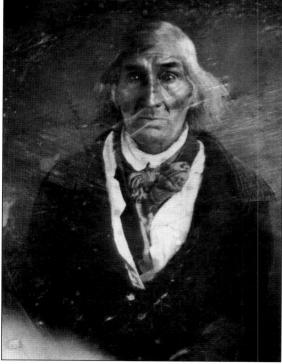

Abram Quary was the last living male Wampanoag on Nantucket. Later in life, he lived in a shack in Shimmo (its location is now called Abram's Point), and when the near-hermit was amenable to company, he would raise a white flag, and parties of visitors would sail up-harbor to partake of his clambakes. (GPN4336, photographer unknown.)

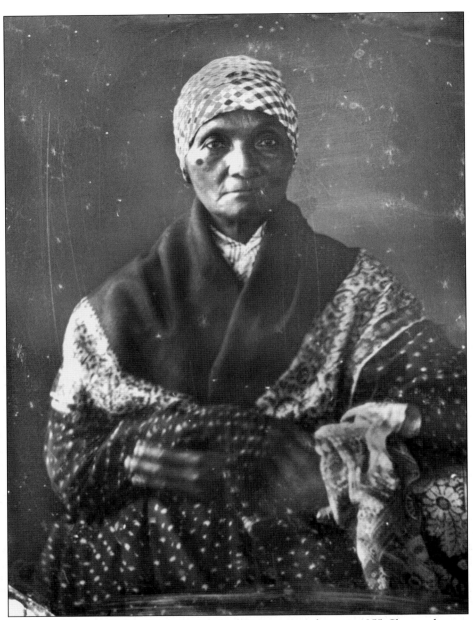

Dorcas Honorable was the last living Nantucket Wampanoag, dying in 1855. She was born in the late 1770s to a dwindling population of Wampanoags. At the time of European arrival on Nantucket, the population may have been as much as 3,000. In the winter of 1763–1764, during the so-called "Indian sickness," 222 of the 358 Wampanoags died. Reportedly, the original contagion was from a quarantined Irish brig anchored offshore. The first taken ill was Mary Norquartal, who washed some of the clothes from the ship. Also, several bodies were thrown off the ship, and contagion may have been made through the burial of their bodies. The description of the disease includes a yellowing of the skin; it is difficult to diagnose the illness now, but it may have been yellow fever. Only one non-native person was affected. (GPN4321, photographer unknown.)

Two

A BUSTLING COMMUNITY

Beginning in the 18th century, Nantucketers turned to offshore whaling for their livelihood. Early efforts took whales close to shore, but Nantucket whaleships began hunting farther afield for the sperm whale and its spermaceti, a waxy substance that burns with a bright, clear flame. Whale oil was used as an industrial lubricant and to light streets, homes, and businesses; baleen, used by some whales to filter their food, was employed to make a wide range of consumer goods—from buggy whips to corset stays, as well as fishing poles to dress hoops.

Nantucket whaling grew exponentially but declined during the American Revolution and the War of 1812. The industry recovered after the latter war ended and again began to prosper, expanding into the Pacific Ocean on voyages that often lasted for years. Consequently, the wives of the whalemen had to assume a more independent role, and many took to commercial trades to support themselves. Centre Street between Main and Broad Streets became known as Petticoat Row because of the large number of women merchants doing business there, selling everything from household goods to more exotic items. The influence of the dominant Quaker faith, which held women as equal to men, promoted such independence.

Mary (Coffin) Starbuck (1645–1717) led the early Quaker movement on Nantucket. The Quakers dominated island life for most of the 18th century; their devotion to simplicity and their conservative nature influenced Nantucket's architecture, business, and society. The Revolutionary War and the War of 1812 were disastrous for the Nantucket Quakers. Their doctrine of pacifism and close commercial ties with Great Britain won them no friends with the mainland colonists.

As the hold of Quakerism on Nantucket weakened, other faiths attracted members. The Congregationalists grew in number and eventually split into two groups: the original meetinghouse on Centre Street and the Second Congregational Meeting House on Orange Street, now Unitarian Universalist. Modest Nantucket lean-tos gave way to mansions like the Hadwen House and the Three Bricks. By the late 1860s, only a few Quakers remained on the island, and by the beginning of the 20th century, the Quaker movement on Nantucket was only a memory.

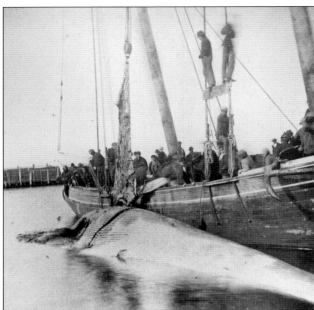

Nantucket was the whaling capital of the world in the late 18th and early 19th centuries. In the later part of this period, whaling voyages lasted for several years. A hand on a whaling voyage worked for a lay, or percentage of the profits, and started a voyage often owing money for his supplies. If a voyage did not make a profit, the man might come home after a long voyage in debt. (P6405, photograph by Josiah Freeman.)

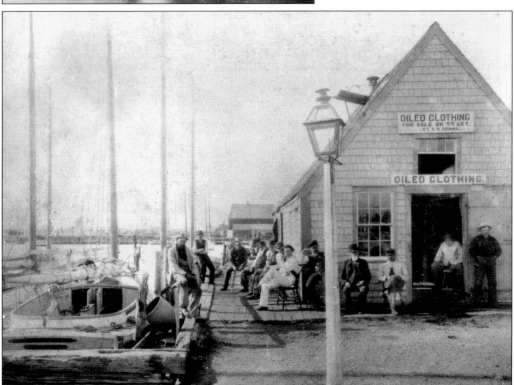

Whaling vessels hunted and rendered the whale onboard the whaleship, making it an odiferous endeavor. Oil, blood, and muck permeated the entire ship. The photograph shows Adams Boat House at Adams Slip on Steamboat Wharf, where oiled clothing was available for sale or rent. (P13377, photographer unknown.)

Owen Chase was the first mate on the now famous 1820 voyage of the ship *Essex*, which was sunk by a sperm whale in the South Pacific. The crew evacuated into three boats but did not make for nearby Tahiti, as they were afraid of cannibals. Instead, Chase persuaded the captain, George Pollard Jr., to make for South America, several thousand miles away. Over the three months adrift in the boats, many of the sailors died. When overwhelmed by thirst and hunger, they began to cannibalize their deceased crewmates. Later, the crew drew lots, and the losers were killed and eaten. Eight members of the crew survived. The book that Chase wrote of his experiences inspired Herman Melville to pen a tale of another whaling voyage, *Moby-Dick*. At the end of his life, Chase hoarded food in the attic of his house at 74 Orange Street and complained of headaches; he was declared insane in 1868 and died in the Quaise Asylum in 1869. (GPN4448, photographer unknown.)

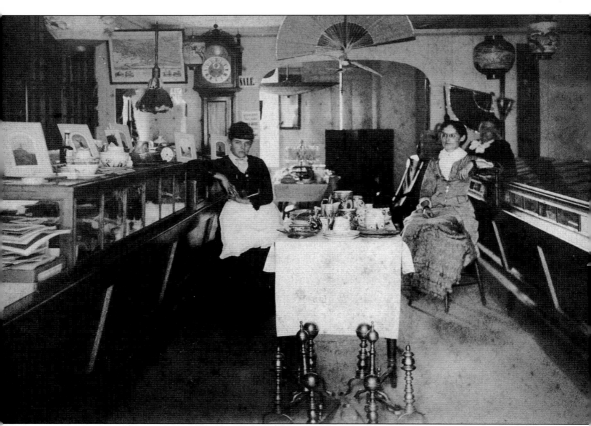

While men went whaling, much work remained to be done in the bustling town of Nantucket; that work was done by women. So many of the shops on Centre Street were owned and operated by women, it was called Petticoat Row. The stores on Petticoat Row sold everything from basic necessities to merchandise from exotic locations. Quakerism, which supported an expanded role of women in the public sphere and valued hard work, was also a significant factor in the acceptance of woman-owned businesses. A poem found in the back of a journal kept by Eliza Brock between 1853 and 1856, "Nantucket Girl's Song," records a sentiment revealing that many women treasured this freedom: "I have made up my mind now to be a Sailor's wife, To have a purse full of money and a very easy life, For a clever sailor husband is so seldom at his home, That his wife can spend the dollars with a will that's all her own." This 1881 image shows the interior of Mary Nye's shop. (P3425, photograph by Henry S. Wyer)

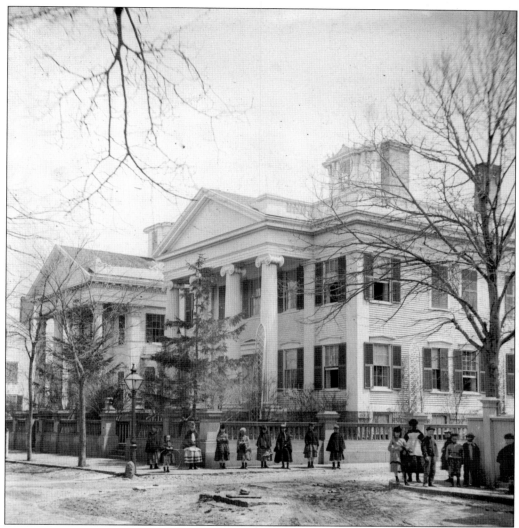

William Hadwen came to Nantucket in 1820. He soon married whale baron Joseph Starbuck's daughter Eunice, whom he had met at the wedding of his cousin Nathaniel Barney to Eliza Starbuck. In 1829, William went into partnership with cousin Nathaniel as whale-oil merchants. At first, the two families lived together at 100 Main Street and had a tryworks for rendering whale blubber in their backyard. In 1849, Hadwen and Barney purchased Richard Mitchell's candle factory, which is now the site of the Nantucket Whaling Museum. Hadwen built the Greek Revival mansion at 96 Main Street in 1845. The architect was local builder Frederick Brown Coleman. William and Eunice had no children of their own, and nephew Joseph Barney eventually inherited 96 Main Street and Hadwen's cottage in Siasconset. Hadwen also built 94 Main Street for his wife's niece Mary G. Swain Wright. The Hadwen House was acquired by the Nantucket Historical Association in 1965 and is open to the public every summer. (GPN-shute-50, photograph by Charles H. Shute & Son.)

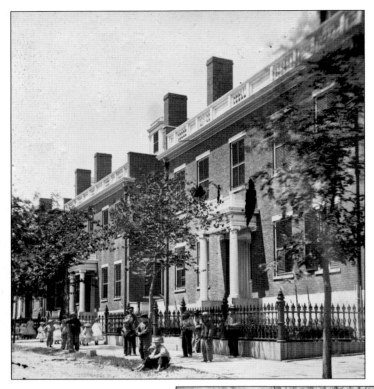

Whaleship owner Joseph Starbuck had three identical houses built for his three sons in 1838. West Brick, at 97 Main Street, went to George, his oldest son; Middle Brick, at 95 Main Street, went to the middle son, Matthew; and East Brick, at 93 Main Street, went to his youngest son, William. (GPN3286, photograph by Josiah Freeman.)

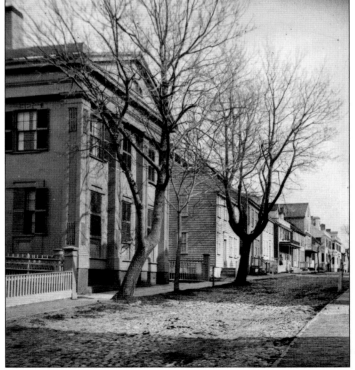

Orange Street was known as the street of whaling captains because many of them built houses there. The house on the left at 14 Orange Street is an example of Greek Revival architecture and was built on what was known as Quanaty Bank. (GPN-shute-47, photograph by Charles H. Shute & Son.)

In the 18th and first half of the 19th centuries, Quakerism was the dominant religion on Nantucket. Its tenets included adhering to simple, plain clothing and avoidance of worldly ways. This photograph shows Mrs. Gorham Hussey (probably Lydia Macy Hussey, July 1, 1798–March 6, 1885) knitting, dressed in Quaker garb. (GPN3332, photograph by Henry S. Wyer.)

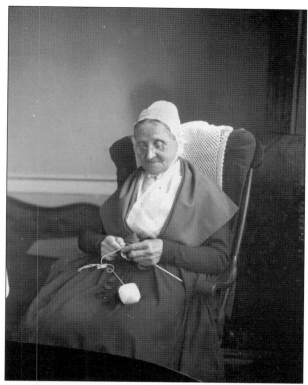

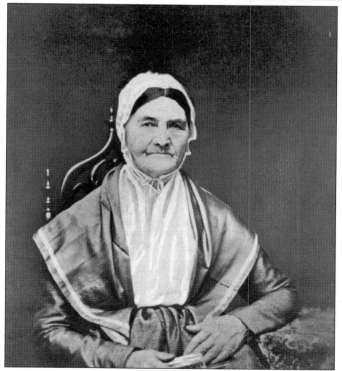

When Quaker Jedida Swain Lawrence's husband and her eldest daughter died in a shipwreck in 1809, she was pregnant with triplets. With seven children to support, Jedida opened a dry goods store on Petticoat Row. She is dressed in traditional Quaker clothing, including a shawl and silk cap. (SC763-8, photographer unknown.)

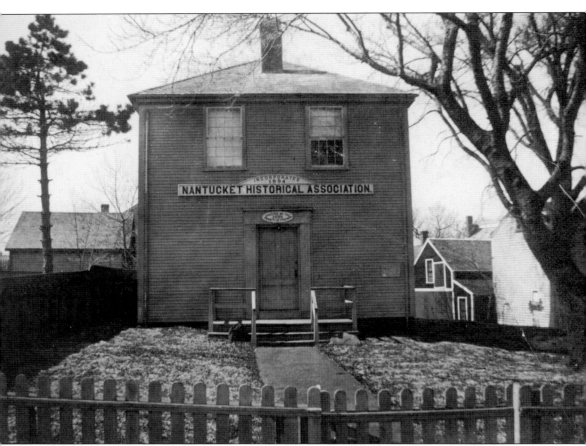

By 1761, the Meeting of the Society of Friends (Quakers) included 4,000 people. The philosophical simplicity reflected the staunch character of Nantucketers and also provided social cohesion; however, the faith was also characterized by a rigid social control. Members were disowned for associating with non-Quakers, playing the piano, dancing, being frivolous, and so on. The Quakers reacted by splitting into factions: the Hicksites, the Gurneyites, and the Wilburites. This factionalism destroyed the religious unity of the island. Other congregations, notably the more liberal Unitarians, grew. By 1870, there were few Quakers on the island. The Quaker Meeting House at 7 Fair Street was originally built in 1838 as a school for the Wilburite sect with a larger building, the South Meeting House, next door. In 1864, it was converted to be a meetinghouse, and South Meeting House was sold and removed. This building was the first property owned by the Nantucket Historical Association, acquired in 1894. (P3414, photographer unknown.)

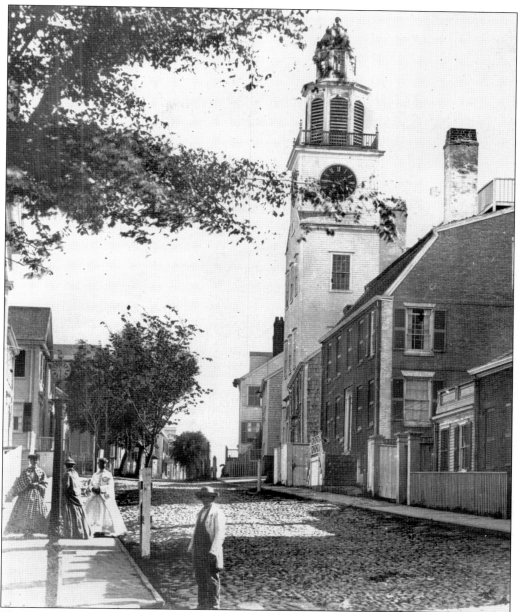

The Second Congregational Meeting House on Orange Street was built between 1809 and 1810. The congregation had split off from the Congregational Church on Centre Street and adopted the "Harvard Covenant" of Unitarian principles in 1837, merging with the Universalists in 1961; it is now a member of the Unitarian Universalist Association. The Orange Street church was called South Church, and the Centre Street was known as North Church. The first town clock was installed in the tower in 1823 and has been replaced twice. The bell is struck 52 times after striking at 7:00 a.m., noon, and 9:00 a.m. The tower was used by Billy Clark, the town crier, for spotting incoming ships and, during World War II, to watch for enemy planes. In 1844, the trompe l'oeil interior was painted by Carl Wendte. In 2011, the painting was restored to its original beauty. (GPN572, photographer unknown.)

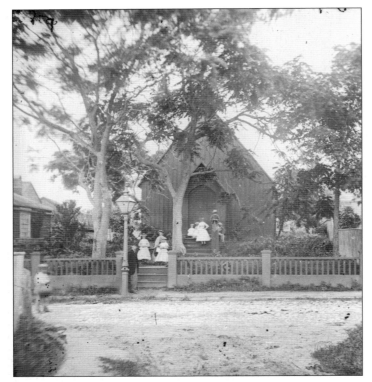

The Episcopal presence was established on Nantucket in 1838, when Trinity Episcopal Church was built on Broad Street, next door to the present Jared Coffin House. The original building on Fair Street, St. Paul's Episcopal Church, was opened in 1850 as a simple wooden structure with vertical boards. The current stone building was constructed in 1902 and features exquisite Tiffany windows. (GPN696, photographer unknown.)

The Methodist church was built in 1823. Until that time, the Methodist Society had met at the town hall at the corner of Main and Milk Streets. The original building was nearly square, with an auditorium and balcony seating 1,000. In 1840, the building facade was remodeled by Frederick Brown Coleman, adding the stately Greek Revival portico. (P6372, photograph by Charles H. Shute & Son.)

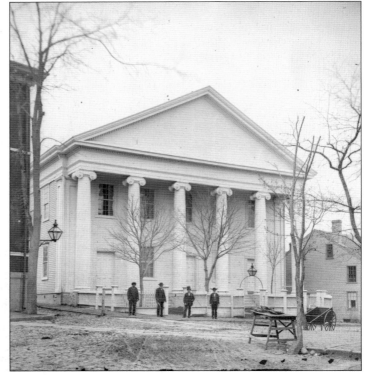

The First Congregational Church on Centre Street was constructed in 1834 by Samuel Waldron of Boston. The original steeple was 123 feet tall; in 1840, the top 25 feet were removed and the four minarets were put in place. The building was completely restored in 1968, with a new steeple hoisted into place by helicopter. The building is also referred to as North Church or North Tower. (GPN2618, photographer unknown.)

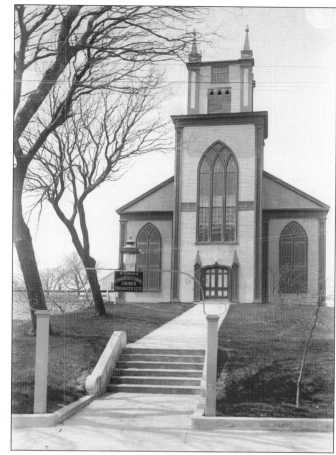

The Old North Vestry was originally built as a meetinghouse in Old Sherburne in 1732. It was moved to the location of the present Congregational church in 1765. This area was once called Beacon Hill. In 1835, the vestry was moved to the back of the lot and now serves as the winter quarters of the Congregational church. (GPN2631, photograph by Henry S. Wyer.)

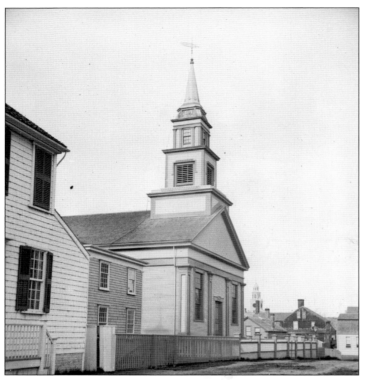

Summer Street Baptist Church was built in 1840. The architect was Frederick Brown Coleman, and the Greek Revival style was interpreted in a very restrained fashion by builder John Chadwick. It has been in continuous use by Baptists since its construction. (GPN-shute-20, photograph by Charles H. Shute & Son.)

The original Quaise Asylum, built in 1822, housed indigent, aged, and chronically ill men, women, and children. On the night of February 21, 1844, a terrible fire killed 10 of the residents. In 1854, the building was moved to Orange Street; it was renamed Our Island Home in 1905 and was used chiefly as a hospice. In 1981, it was renovated to become Landmark House, an independent-living facility. (GPN-shute-39, photograph by Charles H. Shute & Son.)

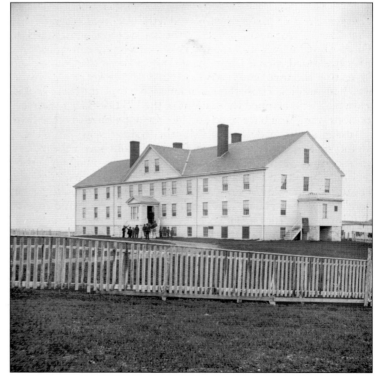

Three

PRESERVATION THROUGH DECLINE

The great fire of 1846, the Civil War, and the discovery of petroleum brought down the curtain on Nantucket's golden age of prosperity; the island's economy declined, and its population plummeted. Those who remained continued to eke out a living through farming, commercial fishing, and other livelihoods gleaned from the sea. Great Point light and Sankaty light, essential to mariners navigating the treacherous shoals around Nantucket, were manned day and night by keepers and their families. Those ships that failed to escape the hazards of local waters were aided by the brave men who manned the stations of the US Life-Saving Service. Risking life and limb daily, its motto was, "You have to go out, but you don't have to come back."

Attempts were made to establish other industries as well: a silk factory complete with steam engine, six looms, four spindles, 500 bobbins, and one of the only two power looms in the world was incorporated in 1836. Alas, even with all that technology at their disposal, the owners had to close up shop within a decade. A straw-hat factory in the building that later became the Dreamland Theatre was founded by Erastus P. Carpenter, who had built the largest straw-hat factory in the world in Foxborough, Massachusetts, and also planned and supervised the building of the Sea Cliff Inn on Nantucket. The hat factory fared no better than the silk factory.

Regardless of the state of the economy, Nantucket's tradition of valuing universal education persisted, fostered by the efforts of education pioneer Cyrus Peirce, the first principal of Nantucket High School when it opened in 1837. For many years, there was a North School (for those north of Main Street) and a South School (from Flora Street south to Newtown). The North School was a wooden building on Academy Hill, which was eventually replaced by the brick building that is there today and has been converted into apartments for senior residents; the South School was on Orange Street and is now gone. A fierce rivalry existed between the two—woe to the student who strayed into the territory of the other school.

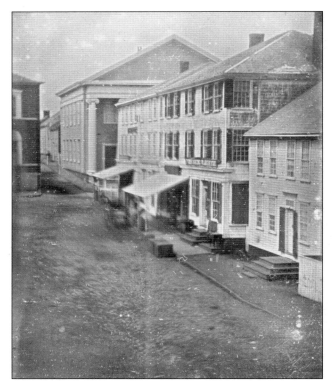

This is the only known photograph of Nantucket prior to the great fire of 1846, showing the north side of Main Street with a partial view of the Pacific Bank and the Methodist church. This block was moved back approximately 30 feet during the rebuilding after the fire to widen the square. (C225, photographer unknown.)

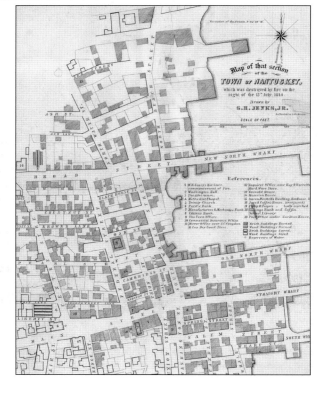

On the night of July 13, 1846, a fire started in a hat store on the south side of Main Street that consumed a third of the town. In response to a plea from the town selectmen, many cities in New England sent supplies and funds to help rebuild. The fire was a significant factor in Nantucket's economic decline. This map was drawn by Samuel H. Jenks, editor of the *Inquirer*, the local newspaper. (MS1000-4-3-11, map by Samuel H. Jenks.)

This view from the Unitarian Universalist Church tower shows the temporary buildings on the south side of Main Street constructed after the great fire of 1846 and the lonely Brant Point lighthouse, not yet engulfed by development. Note the gardens in the backyards of many of the houses. (GPN-shute-2, photograph by Charles H. Shute & Son.)

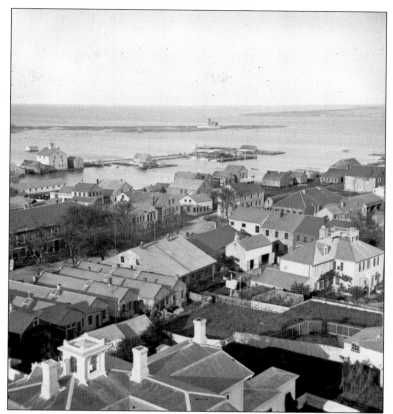

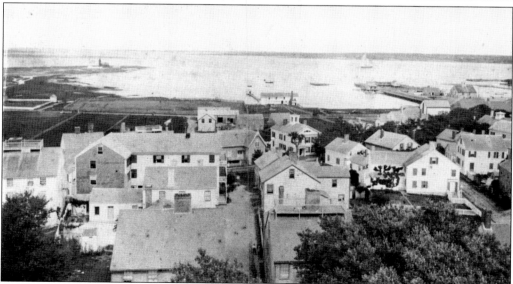

This view from the First Congregational Church tower shows an underdeveloped waterfront, Hayden's Bath Houses, the Brant Point lighthouse, and the edge of the roller rink. Hayden's Bath Houses offered heated saltwater baths, which were believed to be very healthful. (P9576, photographer unknown.)

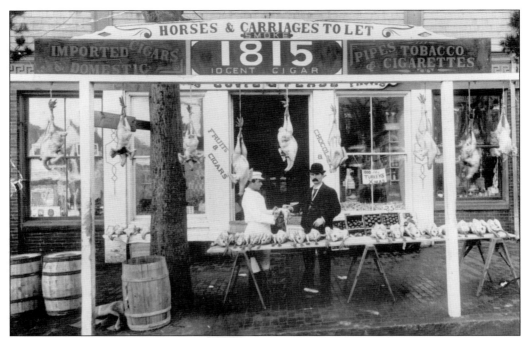

This image shows the Covil and Pease grocery store at 30 Main Street. Numerous signs advertise its wares, including fruits, cigars, chocolates, Christmas turkeys (many of which are on display outside), and horse-and-carriage rental. (F700, photographer unknown.)

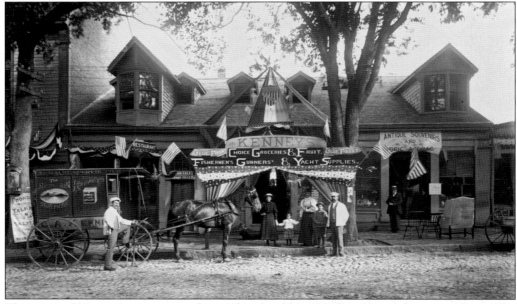

This view of Kenney's grocery on the south side of Main Street shows a busy storefront. The sign above the door reads, "Kenney's Choice Groceries & Fruit, Fishermen's, Gunners' & Yacht Supplies." On the left is a restaurant, and on the right a store advertising "Antique Souvenirs and Bric-A-Brac." The storefronts are decorated with banners and flags, probably for the 1895 centennial celebration. (GPN4483, photograph by Henry S. Wyer.)

The first Nantucket Atheneum occupied the building abandoned by the First Universalist Church. After the private library was destroyed in the great fire of 1846, this was the first public structure rebuilt afterward, opening on February 1, 1847. The architect of this beautiful Greek Revival building was local architect Frederick Brown Coleman. (GPN-shute-22, photograph by Charles H. Shute & Son.)

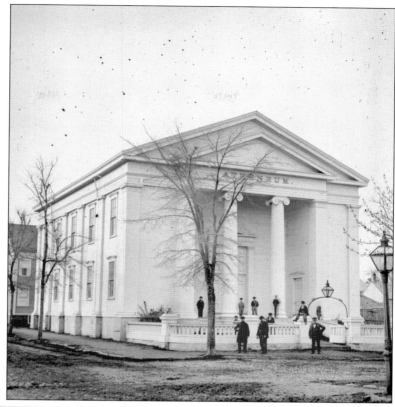

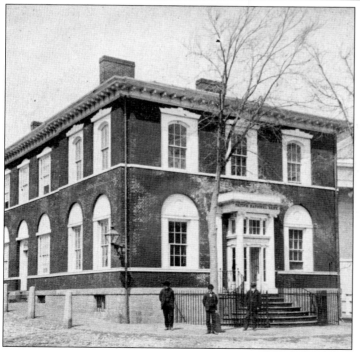

The Pacific Bank escaped serious damage during the great fire of 1846, although the wooden rooftop observatory of William Mitchell was destroyed. When fire wardens wanted to destroy the mansion of bank president John W. Barrett on Main Street as a firebreak, his wife met them on the front steps and said they would have to blow her up, too; the house remained standing. (P6502, photograph by Charles H. Shute & Son.)

Lt. Leander Alley was the first man from Nantucket killed in the Civil War. He traveled the world on a whaleship and joined the Army in response to George Nelson Macy's call for volunteers. He fell at the Battle of Fredericksburg in 1862. His body was returned to Nantucket at Christmastime; schools and businesses were closed for the first military funeral in Nantucket. (C198, photographer unknown.)

The Civil War monument was built using the millstone from the Round-Top Mill as a base in 1874. Seventy-one men were killed during the Civil War, many as members of the 20th Massachusetts Volunteer Infantry. This site also marks the location of the Liberty Pole, erected during the Revolutionary War in front of the then town hall. (GPN2125, photographer unknown.)

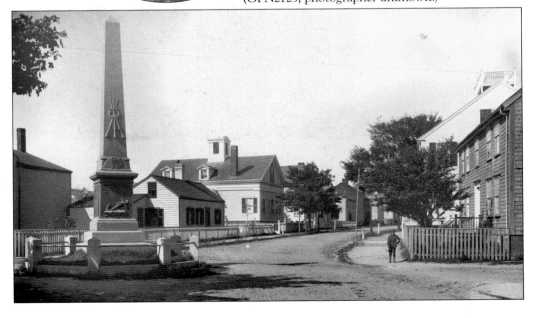

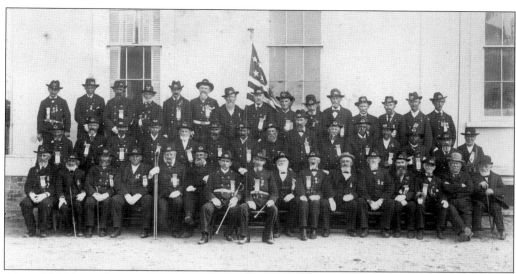

About 300 Nantucket men served during the Civil War; 80 were members of Company I of the 20th Massachusetts Volunteer Infantry, raised primarily by islander George Nelson Macy. This 1909 gathering of Civil War veterans was the Thomas M. Gardner Post, Grand Army of the Republic. (P1574, photograph by John Johnson.)

During the Civil War, islanders were fearful of "piratical invasion" and created their own Island Guard. This militia had about 61 members in 1861, with privately purchased uniforms and daily marching practice. The last three Nantucket veterans of the Civil War are seen here in their uniforms. From left to right are Franklin Murphey, James H. Barrett, and James H. Wood. (P1587, photographer unknown.)

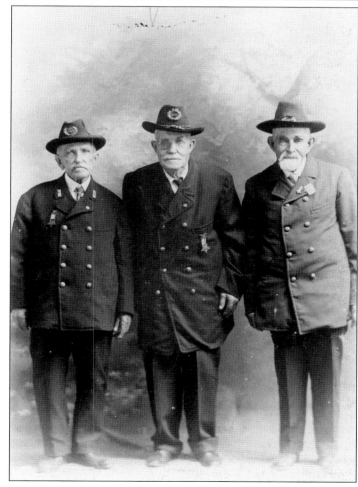

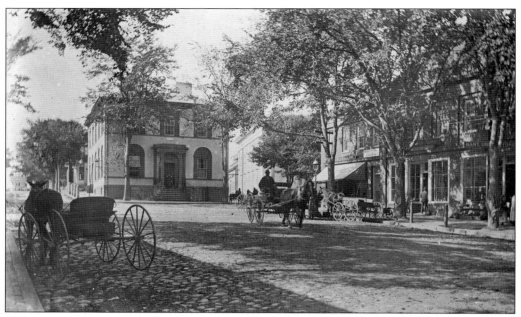

Nantucket has had many banks in its history. The Nantucket Institution for Savings, located in this photograph upstairs at the corner of Main and Centre Streets, was incorporated on April 2, 1834. It is now known as Nantucket Bank. The Pacific Bank (left) was incorporated in 1804. This building was constructed in 1818. Both of these banks are owned by off-island corporations. (GPN4390, photographer unknown.)

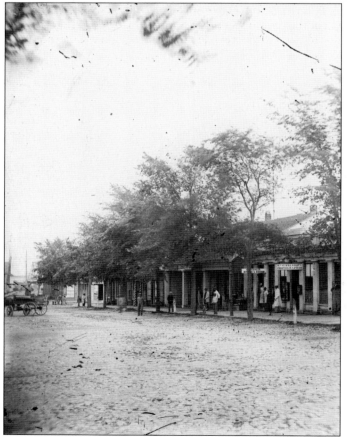

After the great fire of 1846, buildings were quickly erected along the south side of lower Main Street. Meant to be temporary, they were not removed until the late 19th century. This image shows a sign for the business of the photographer William Summerhays, a boot repair store, a barber, and a man selling melons at a small table. (GPN2064, photographer unknown.)

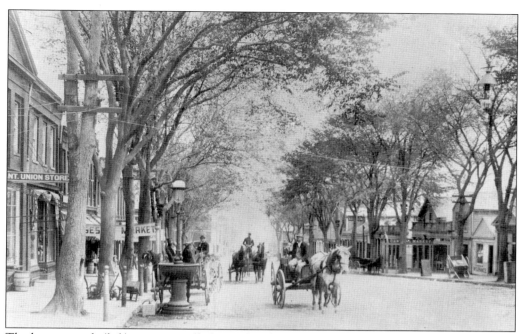

The horse trough (left) was originally located at the head of Main Street, as seen in this image. It was moved to its current position at the bottom of the town square in 1893, at the same time that street lighting was installed in the downtown area. (PH15-1, photographer unknown.)

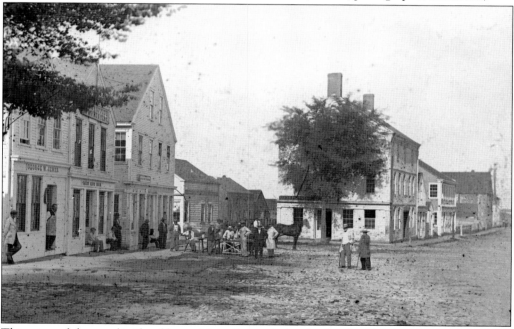

This view of the north side of lower Main Street shows the Pacific Club building at the end of the square, where retired whaling captains met. The two structures on the left at the end of the block are the only buildings that remain in their original locations after Main Street was widened following the great fire. (GPN707R, photograph by Josiah Freeman.)

This is a view of Brooks' Landing on the island of Tuckernuck, off the west end of Nantucket Island. At one time, several families lived there year-round, and it had its own school. Approximately 35 houses are on the island, owned chiefly by descendants of the original inhabitants. Currently, there are only seasonal residents and no paved roads, and its electrical power must be provided

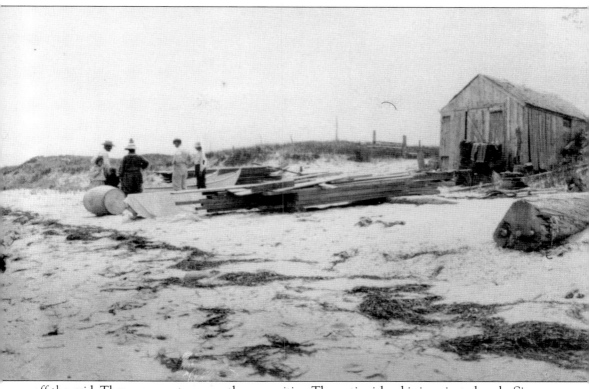

off the grid. There are no stores or other amenities. The entire island is in private hands. Since 1996, the Tuckernuck Land Trust has helped to protect the natural landscape with conservation restrictions. (F3025A, photographer unknown.)

The houses on Tuckernuck were traditionally small, single-family dwellings, which were easier to heat and maintain. The house on the left shows the rear view of the Andrew Brock house, later owned by the Brooks family. In the background is the only hotel ever on Tuckernuck, owned by the Dunhams. (GPN450, photographer unknown.)

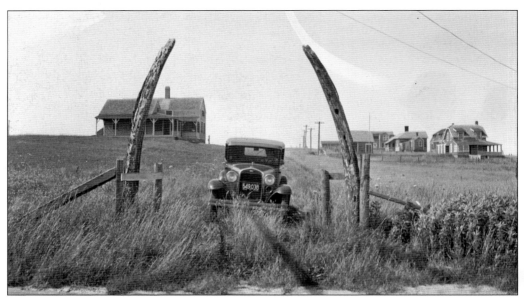

Nantucket has several villages, or small enclaves of houses and families. The population of these communities expands in the summer, but there are always year-round residents in each. These include Madaket, Tom Nevers, Shimmo, Monomoy, Quaise, and Quidnet. Quidnet, pictured here, had gateposts of whalebone for many years. (PH15-11, photographer unknown.)

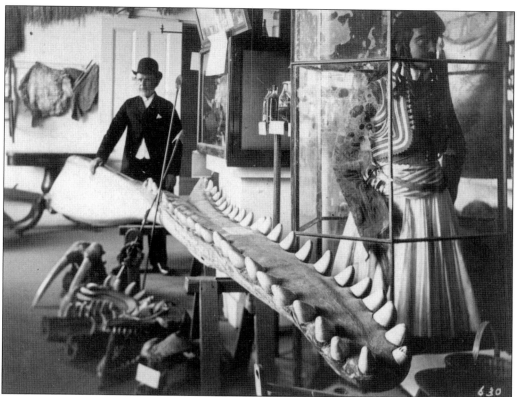

The Nantucket Atheneum originally was a true athenaeum, with a private library, speaker program, and a museum of souvenirs from the South Seas. Joseph Swain, pictured here, was a curator of the collection. Much of this collection was later donated to the Nantucket Historical Association. (P3034, photograph by Harry Platt.)

As the economy declined, efforts were made to encourage residents to stay on the island and pursue farming as a business. The Nantucket Agricultural Society, established in 1856, displayed vegetables, fruit, and handmade items each year at an annual fair at the athenaeum. The fairs continued until 1934, with ever-lessening attendance. (GPN3882, photographer unknown.)

Through the end of the 19th century, Nantucket Island continued to be chiefly underdeveloped landscape. Contrary to legend, Nantucket was not once forested, and Europeans did not cut all the trees down. This view shows a curve in Polpis Road near Folger's Marsh that was removed when the road was straightened by the state. (F4951, photographer unknown.)

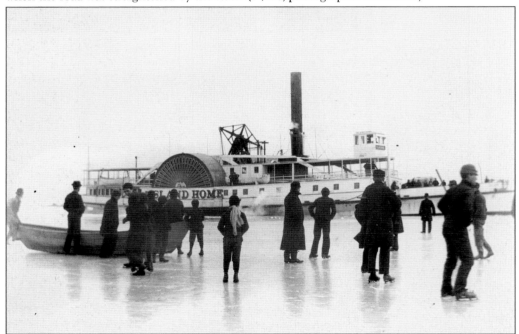

As an island, Nantucket has always been dependent on the ferry service to deliver food, mail, and other supplies. When the sound froze up, supplies and people were often hauled from the boat over the ice to the island. Occasionally, the boat was frozen in place. Here, the steamship *Island Home* is stuck in the ice in 1893. (F3059, photographer unknown.)

The British bark *Minmanueth* ran aground in 1873 on the south shore near Miacomet Pond. Spectators watch as cargo was removed to lighten the load before towing the ship away. When ships ran aground or wrecked near the island, Nantucketers often salvaged goods from them. (P6454, photograph by Josiah Freeman.)

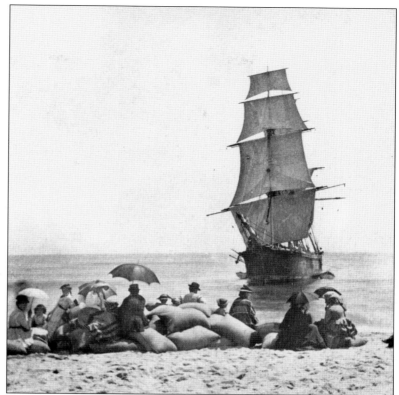

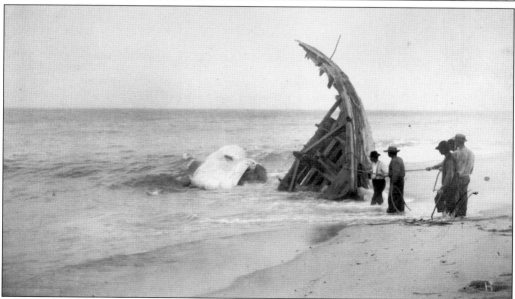

The *Warren Sawyer*, carrying cotton and scrap iron, ran aground on December 22, 1884. Lifesavers were able to save the crew and much of the cargo. Some of the cotton was salvaged by individuals and sold. The wreckage was visible for almost a year. In September 1885, a whale washed up at the same spot. (P3179, photograph by Henry S. Wyer.)

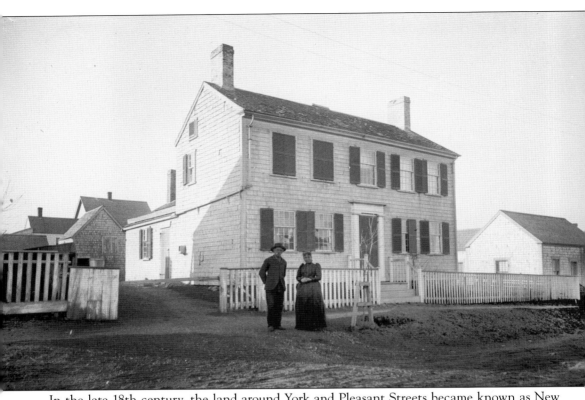

In the late 18th century, the land around York and Pleasant Streets became known as New Guinea, as many people of color made their homes there. African American and Cape Verdean residents, along with other minorities, created a strong community with their own school, church, and businesses. Edward Pompey sold many subscriptions to the black abolitionist newspaper *The Liberator* to people who lived here. Absalom Boston, born in Nantucket in 1785 to an ex-slave father and Wampanoag mother, was the captain of the *Industry*, a ship with an entirely African American crew, in 1822. In 1845, he brought suit against the town to have his daughter Phebe Ann Boston admitted to the Nantucket public high school, eventually leading to desegregation of the schools. Samson Dyer Pompey and his wife, Susan Kelley Pompey, pictured here in front of their house at 3 Atlantic Avenue, were also community leaders. (GPN1816, photograph by Henry S. Wyer.)

Anna Gardner (1816–1901) was raised in an abolitionist family and taught at the African School (pictured below). Eunice Ross, one of her pupils, was denied entrance to the Nantucket High School because of her race, and Gardner resigned her position. She then led the call for desegregation of the Nantucket public schools, which was achieved in the 1840s. (GPN4320, photograph by Edwin B. Robinson.)

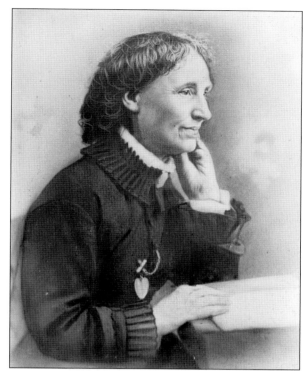

The African Meeting House was built in about 1827. It was a school, church, and centerpiece of the African American community of New Guinea. It, and the York Street residence on the right, was purchased by the Museum of African American History in Boston in 1989 and is open to the public, offering lectures and other events. (P3415, photographer unknown.)

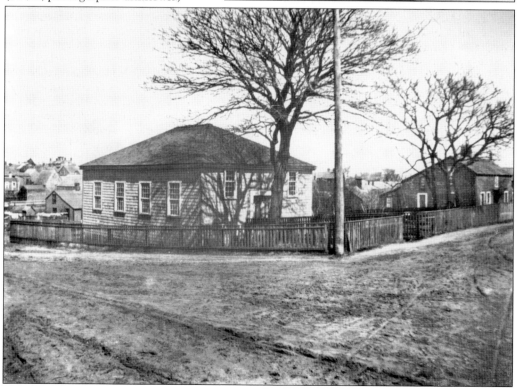

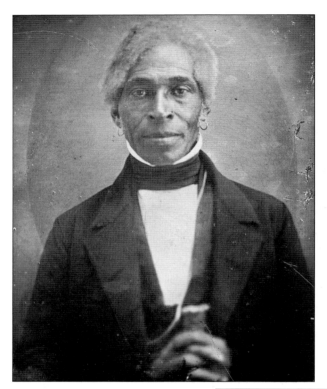

A fugitive from slavery, Arthur Cooper arrived in Nantucket with his family in 1820. Two years later, when an agent for his former owner came to the island, intending to take Cooper, as well as his free-born wife and children, into slavery, Nantucket Quakers assisted in their rescue. Many Nantucketers owned slaves before Quaker Benjamin Coffin wrote the island's final deed of manumission in 1775. The state followed Nantucket's example in 1783. (P16846, photographer unknown.)

Whaling vessels often recruited sailors from the Cape Verde islands. Some of these men raised families on Nantucket. Later, more Cape Verdeans came to Nantucket to pick cranberries. The community remains a central part of Nantucket's cultural landscape. This photograph shows Capt. Manuel Gomes. (P14367, photographer unknown.)

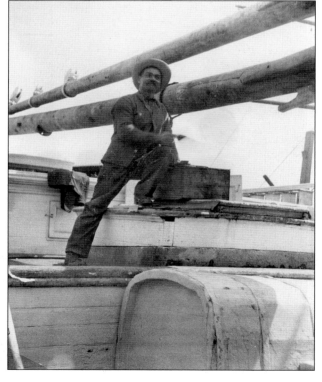

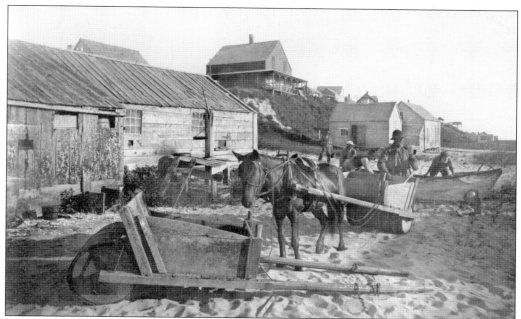

In the early 19th century, Codfish Park was the home of many families of African American and Cape Verdean descent, as well as other ethnic groups. This area was typically referred to as "downbank," and the main part of Siasconset was "upbank." Codfish Park was filled with small homes and fishing shacks. The area is a large beach that has been susceptible to washouts and flooding. There were few roads and no amenities, although there was at least one snack shop selling hot dogs and candy during the 1920s. Many of the wealthy summering Siasconset residents roomed their house staff in Codfish Park. The photograph above shows fishermen with fishing drays, carts that have a barrel as a wheel. The photograph below features the Gulley from upbank. (Above, P2564, photograph by Baldwin Coolidge; below, P21974, photographer unknown.)

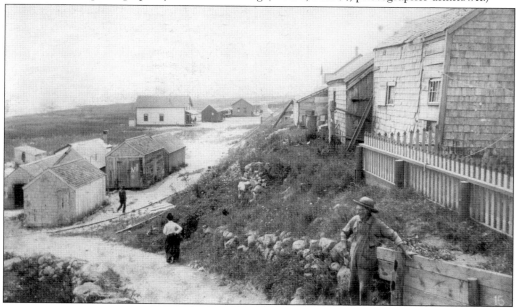

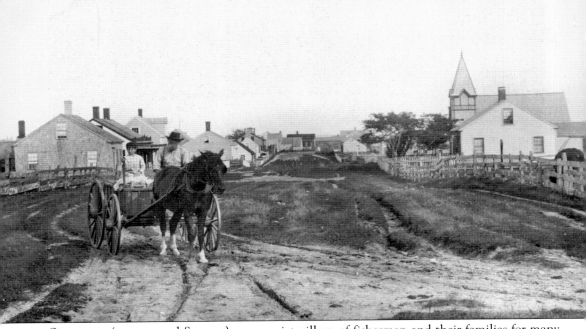

Siasconset (pronounced *Scon-set*) was a quiet village of fishermen and their families for many years before it became a popular summering community. Nantucketers who lived in town during the 19th century often had cottages in Siasconset that they used for summer breaks. The name *Siasconset* comes from the Wampanoag word for "place of great bones." Alfred Folger, driving this wagon, made ice cream. 'Sconset Union Chapel, built in 1883, is at right. By 1886, the chapel was enlarged because the services were so well attended and it had become a popular wedding venue. Electricity was installed in 1922, and the entrance was moved in 1966. 'Sconset Union Chapel continues to offer nondenominational Christian services. (A15-11, photograph by Henry S. Wyer.)

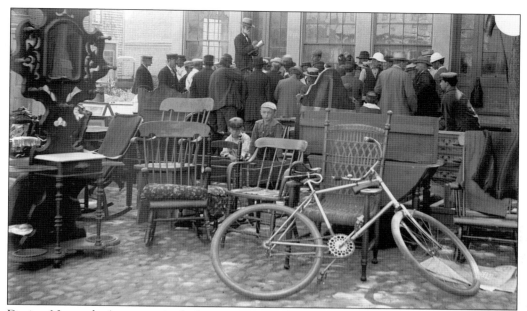

During Nantucket's economic decline, many people moved away. Popular destinations were Hudson, New York; New Garden, North Carolina; and California after the gold rush, selling as much as they could in auctions such as these. Many auctions took place on Main Street at the auction house of Andrew Myrick at the corner of Main and Washington Streets. (GPN2564, photograph by Henry S. Wyer.)

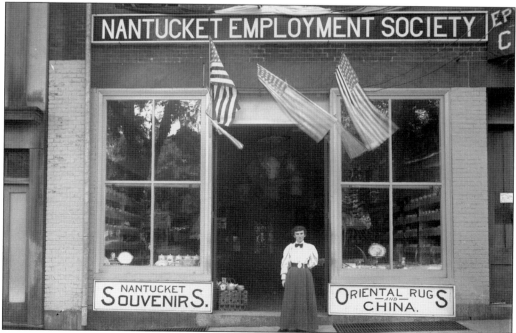

Unemployment was rampant in Nantucket after whaling ended. The Nantucket Employment Society was at 50 Main Street. The Sherburne Debating Club was formed to hold weekly debates under the supervision of the employment society. (GPN2077, photograph by Henry S. Wyer.)

During the economically depressed times, there continued to be work in farming and other industries. Nantucket and Siasconset were served by several local farms and dairies. Pictured here is Horace Jernegan delivering ice to homes in Siasconset; the icehouse was on New Street. (A32-78, photographer unknown.)

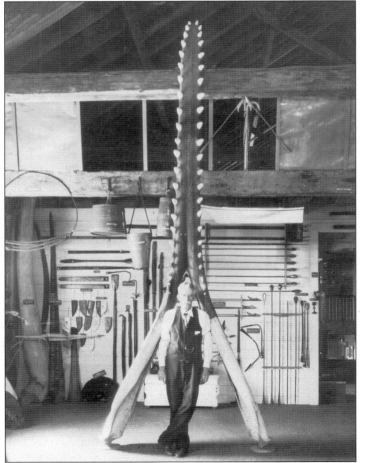

George A. Grant (1857–1942), the son of a whaling captain, was born on the island of Upolu in Western Samoa; he was brought onboard the *Mohawk* at three weeks old, wrapped in a banana leaf. Grant served on a whaleship for 33 years and at the Surfside Life-saving Station for 19 years before becoming curator of the Nantucket Whaling Museum. (P14996, photographer unknown.)

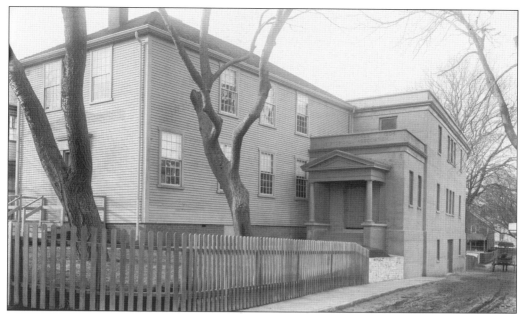

In 1894, the Nantucket Historical Association (NHA) was formed to collect and preserve items of historical interest. In June 1894, the NHA purchased the Friends Meeting House on Fair Street and set up its first headquarters. By 1904, the collections required more space, and a fireproof, poured-concrete building was added. In 2001, the building was remodeled to serve as the NHA Research Library, which included a climate-controlled vault. (GPN2841, photographer unknown.)

The interior of the Quaker Meeting House on Nantucket during its use as a museum for the Nantucket Historical Society collections shows the curiosity cabinet–like appearance of the exhibitions. The large doll is the Dauphin, a wax doll of the lost prince of France, last placed on exhibit in the summer of 2011. (P9326, photographer Henry S. Wyer.)

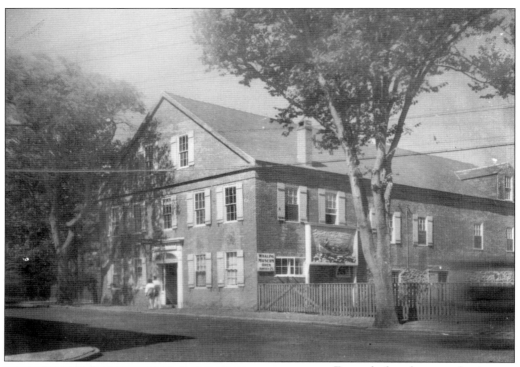

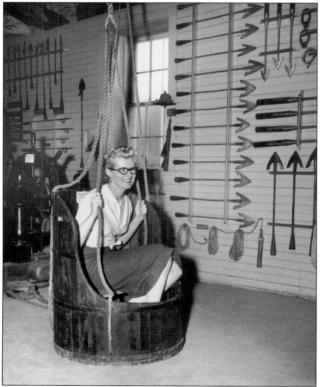

Erected after the great fire in 1846 by the Mitchell family, this building was used by William Hadwen and Nathaniel Barney as a candleworks through the 1860s. After use as a warehouse, steamship office, and antiques store, it was purchased in 1929 by Edward F. Sanderson, who enabled the Nantucket Historical Association to acquire the property. It opened its doors as the Nantucket Whaling Museum in 1930. (F4746, photograph by Leonard W. Gibbs.)

A visitor is seated in the gamming chair in the whaling museum in the 1950s, before the renovation. This was used to transport people safely between two ships, for a gam, or conversation. The chair and the harpoons, mounted on the wall behind her, remain on display. (P4446, photographer unknown.)

Four

THE RESORT RENAISSANCE

While the local community struggled through the mid- and late-19th century, people in America were beginning to rediscover Nantucket, but not for its mercantile prospects; instead, they valued its quaintness, the healthful air, and scenic views. In the last decade of the 19th century, a summer colony of artists, writers, and actors coalesced, made accessible by the extension of the railroad to 'Sconset in 1884. Accommodations soon followed, as a number of hotels and restaurants like the Chanticleer were established in the late 19th century. With the advent of World War I, the Gatsby-like air of 'Sconset came to an end: the theater colony dispersed, the railroad no longer came to the village, and several hotels closed.

The lull proved to be temporary, and the tourism industry eventually revived throughout the island. As islanders in large numbers turned from the sea for their livelihood, some looked to it for inspiration: a new artist colony came into being in the early 1920s when Florence Lang converted many of the old shacks on the Nantucket waterfront into studios for artists to rent. These waterfront artists brought a new vitality to Nantucket's decayed waterfront and helped to establish Nantucket as a haven for artists of all styles and mediums.

The Great Depression slowed the island's rebirth once again, but World War II saw the arrival of the Navy and an infusion of fresh vigor and talent. Commercial fishing on a large scale declined and has been replaced by the charter-boat and surf-casting visitor. Whales are once again spotted off the south shore of the island. The tourism industry resumed and has been in full swing ever since. Large parcels of open space have been maintained for the enjoyment of all and are carefully managed to protect the many endangered species that retain a toehold on the island. Recent years have seen a transformation of the typical visitor from the day-tripper to the well-heeled parvenu, but the charm and appeal of Nantucket is still available to all who would seek it out.

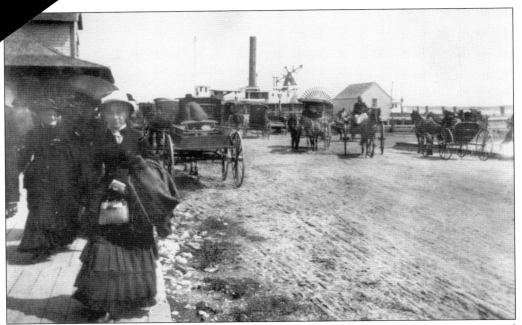

After a steady decline in its economy from the heyday of the whaling era, the island experienced a renaissance as a summer resort and tourist destination. This 1870s image shows visitors leaving Steamboat Wharf, having arrived on the boat. There are carriages for hire and a steamboat at the dock. (F6506, photograph by Harry Platt.)

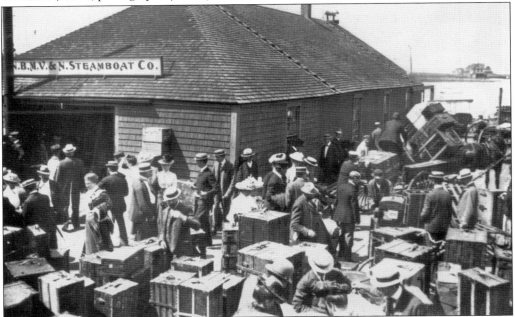

Steamboat Wharf was a lively scene throughout the summer. In this 1900s photograph, crowds of summer visitors try to find their luggage at the New Bedford, Martha's Vineyard, and Nantucket Steamboat Company baggage shed. Passage on the boat was substantially longer than it is today, as the route was more indirect. (F6490, photographer unknown.)

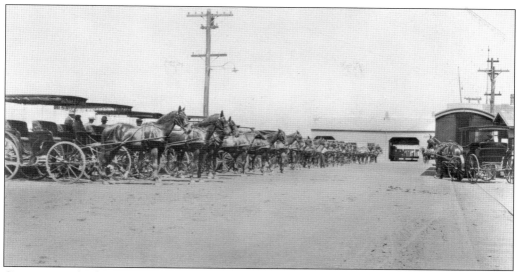

Competition for fares from incoming visitors was fierce. In this c. 1900 photograph, a long line of horse-drawn carriages, including carriages for hire, vie for fares while the train stands ready to take passengers to Siasconset. Many of the local inns, guesthouses, and hotels had their own carriages to cater to clients. (F706, photographer unknown.)

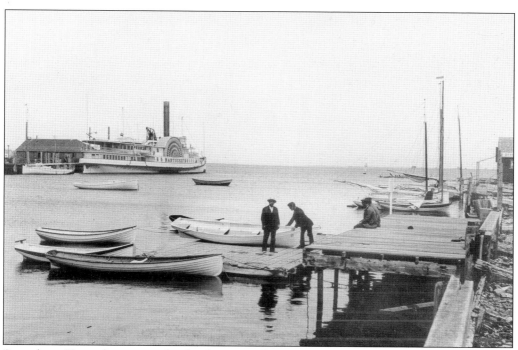

Steamboat *Nantucket* was a side-wheel steamer that was in service to Nantucket between 1886 and 1910. It weighed 629 tons and was 190 feet long. The steamboat was beautifully decorated, featuring an ornately painted paddle-housing and copper fastenings throughout; however, it was not designed for travel on the rough waters of the sound. (P16342, photographer unknown.)

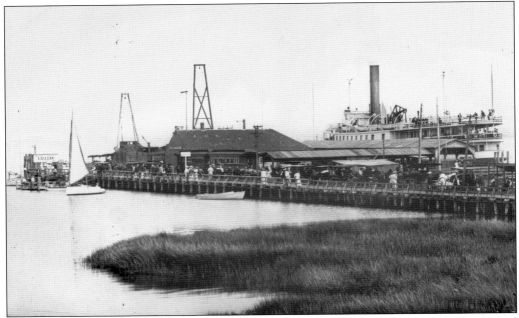

Steamer *Gay Head* was built in 1891 to replace the steamer *Island Home*. It weighed 701 tons and was 203 feet long. The catboat *Lillian* (left) made pleasant excursions daily to take passengers to the Wauwinet Hotel, located at the head of the harbor. The *Gay Head* was retired in 1925. (F1893, photographer unknown.)

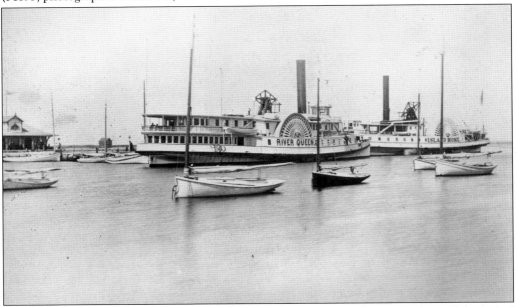

The steamer *Island Home* was built in 1855. The first boat owned by the Nantucket and Cape Cod Steamboat Company, it sailed from Hyannis until where the Old Colony Railroad extended its line to Woods Hole in 1872; the boat then sailed to Nantucket from there. The *River Queen* was in service to Nantucket from 1875; during the Civil War, however, it was used by Gen. Ulysses S. Grant as his private dispatch boat. (SC459, photographer unknown.)

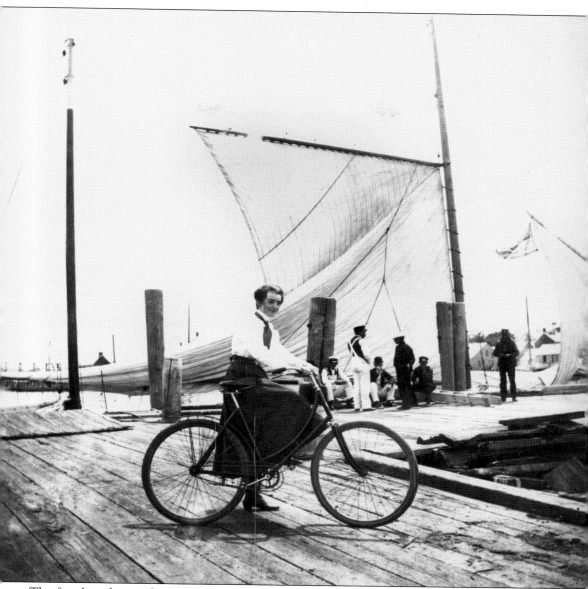

The first bicycles on the island were called penny-farthings, ordinary, or high-wheelers; they had huge front wheels and tiny rear wheels and weighed about 70 pounds. The first Nantucket bicycle was owned by J. Stockley Gary, who reportedly lent it to anyone willing to try riding it on Nantucket roads. For many years, there were a few enthusiasts who rode regularly, performed exhibitions at fairs, and had races. When the safety bicycle became available in the 1880s, bicycling became very popular. A local bicycling club, the Weweeder Cycling Club, helped to popularize the sport. Eugene Burgess built his own quarter-mile track on his property on lower Orange Street, where Marine Home now stands. The first bike path was to Siasconset (built in 1896) and was one of the earliest in the nation. Bicycling continues to be a major attraction for the summer visitor. Several bike paths allow for easy travel across the island, and more planned to be built over the next few years. (F6497, photographer unknown.)

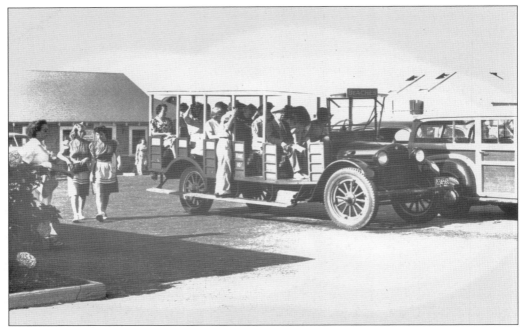

This "beach bus" at the parking lot of the Cliffside Beach Club was available to take passengers to and from the beach in the 1940s. Cliffside offered this service to its clientele. The waitresses (left) could also be seasonal, as many businesses had housing for their staff and recruited off-island. (F2967, photograph by Louis S. Davidson.)

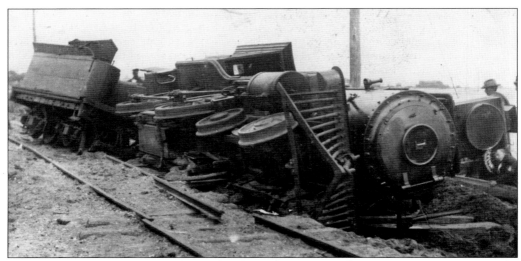

For almost 40 years, the Nantucket Railroad was the most popular way to get to Siasconset, the village on the eastern part of the island. It was, apparently, an unsteady ride. When the line went by the south shore, the tracks were often washed out. This photograph shows a derailment of engine No. 1. Apparently, one engine was buried near where it fell near Washington Street. (P5442, photographer unknown.)

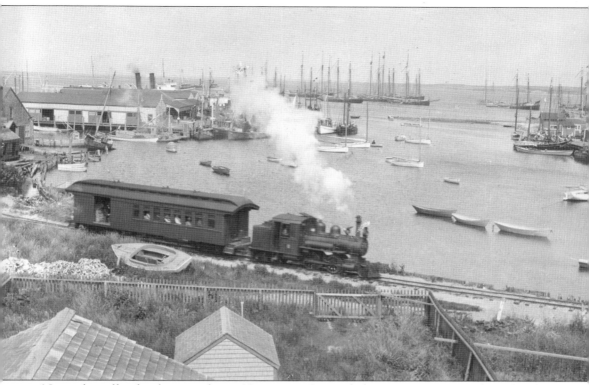

Nantucket offered rail service from 1881 to 1917. Original plans were to go west along the cliff, then around the south shore to Siasconset. But when the track was laid in 1881, it went east and south three miles to Surfside. The narrow-gauge tracks, set three feet apart, the locomotive, and two passenger cars were all secondhand. The engine was named *Dionis*, and the name was set in large gold letters on either side. The train could seat 180 people. There was great opposition to the project from town businesses and taxi drivers, and there were two attempts to sabotage the train in the first year. In 1885, the engine 'Sconset was added, and in 1901, the *Dionis* was replaced with engine No. 1. When the automobile was allowed on the island in 1918, the railway closed, with the rails, two cars, and engine No. 2 sent to Bordeaux, France, for the war effort. (F614, photographer unknown.)

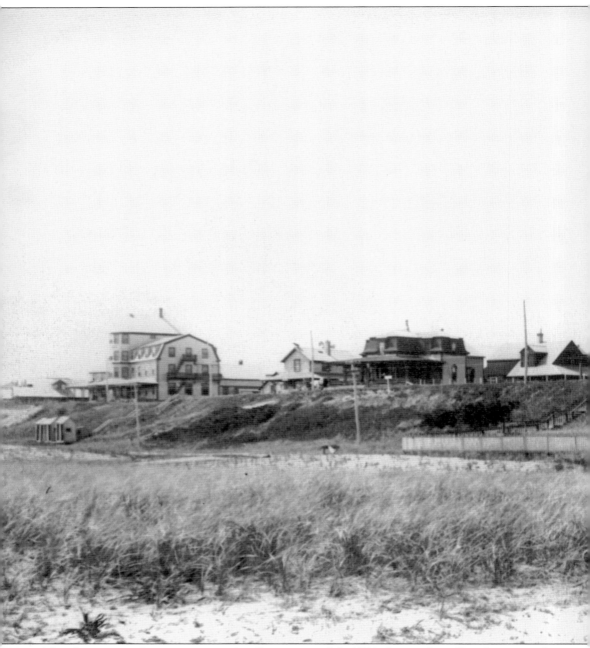

After the train tracks were continued to Siasconset in July 1884, the number of hotels increased. This c. 1900 image shows the houses on the south bluff. Other developments were not so fortunate. The original route of the train in 1881 was to Surfside, where, besides the depot, there was only the Surfside Life-Saving Station and some fishing shacks. In the spring of 1883, a large hotel was imported from Providence, Rhode Island, to become the Surfside Hotel. The newly established

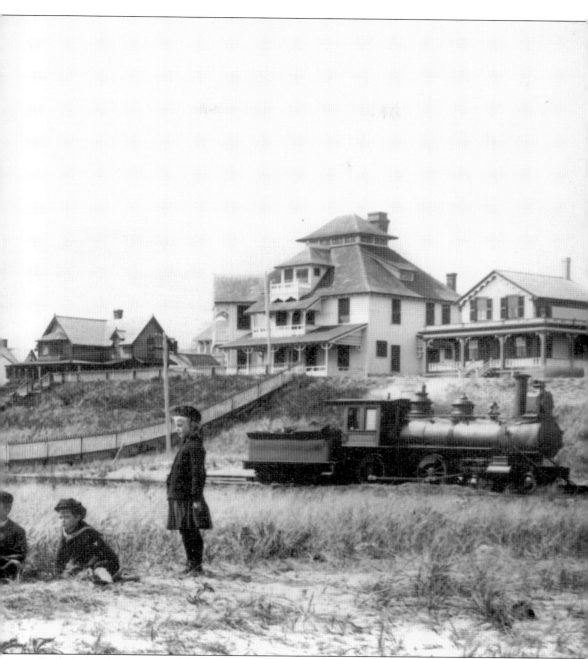

Surfside Land Company sold 180 lots by the end of 1882. However, the track along the south shore was frequently washed out, and financial losses caused the Nantucket Railroad to shut down; it was reorganized into the Nantucket Central Railroad Company, and the route was changed to avoid Surfside. The Surfside Hotel and the land-development scheme quickly went bankrupt. (P5431, photographer unknown.)

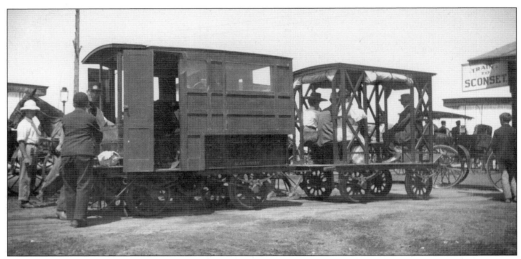

A small gasoline-powered car and its companion baggage car, known as the "Bug" and "Bird Cage," ran to Siasconset from 1907 until 1913. In 1910, the company purchased a larger gasoline-powered engine, but after constant malfunctions, it was returned to the manufacturer. (P12872, photographer unknown.)

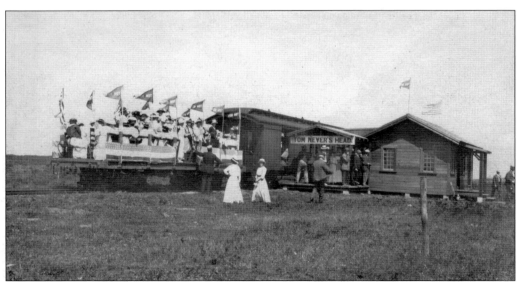

When the railroad changed its route in 1895, it traveled past the old fairgrounds near Old South Road to Tom Nevers before going on to Siasconset. This image shows a crowd of people attending the auctioning of Tom Nevers Lodge. After failing at selling plots in a development plan in Tom Nevers in 1916, Franklin Smith and Edgar Linn built a rambling inn, which also failed. (P9997, photographer unknown.)

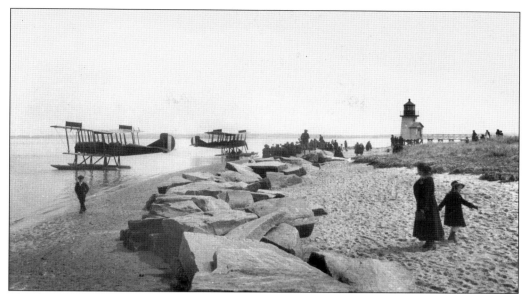

The first airplanes that came to Nantucket in 1917 were unannounced. On April 17, 1918, the Naval Air Station in Chatham alerted the town before sending four hydroplanes. Three R-9s arrived at Brant Point; one spun off while landing at Coatue. The schools declared a holiday, and crowds came to watch. (F4286, photographer unknown.)

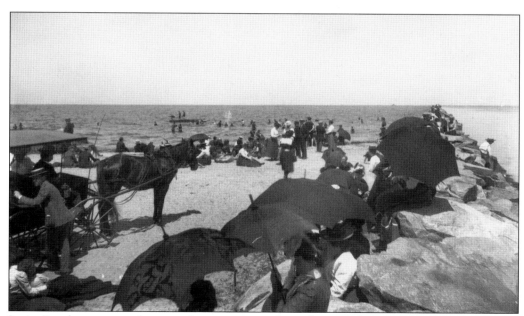

Jetties Beach was as popular a spot for swimming and socializing in the 1900s, as it is now. After the harbor became progressively more inaccessible, the town of Nantucket asked the federal government for assistance in 1800. Eighty-one years later, work began on the western jetty with granite riprap. In 1884, work began on the eastern jetty. (GPN4279, photograph by Henry S. Wyer.)

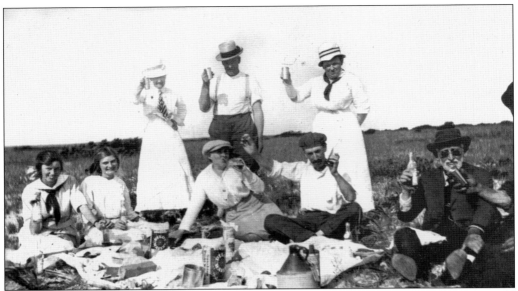

A Nantucket tradition, much beloved by summer visitors, was to have a "squantum." This would be an outing and clambake for a group of convivial friends. Many proprietors of local businesses would provide supplies and transportation for visitors wishing to partake of this local tradition. (F2146, photographer unknown.)

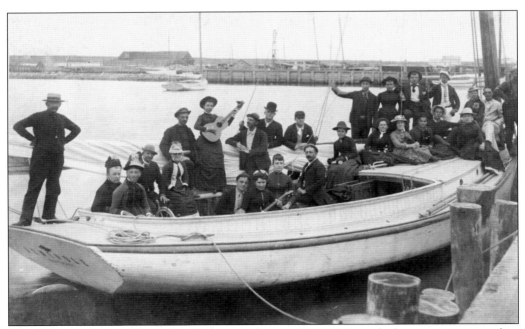

This boating party in Nantucket Harbor on August 16, 1886, is ready for an outing, complete with two women providing guitar music. The *Seminole*, owned by Capt. George Veeder, son of whaling captain Charles Veeder, was one of many catboats for hire at Steamboat Wharf. (P22465, photograph by Harry Platt.)

Many activities of summer visitors and locals alike on Nantucket take advantage of the beautiful Nantucket weather and outdoor activities. Many participate in traditional island activities like clamming, scalloping, and fishing. These two women are dressed to go clamming. (A31-14a, photographer unknown.)

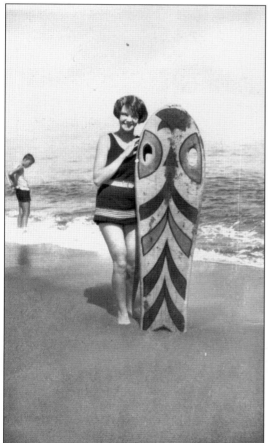

Constance Viola Greene Haroldson is pictured here with her surfboard on Siasconset Beach in 1932. This is the earliest known photograph of a surfboard on the island. Nantucket was known as a summer paradise, where many people, young and old, have gathered to enjoy the fine weather on the beach. (A72-4, photographer unknown.)

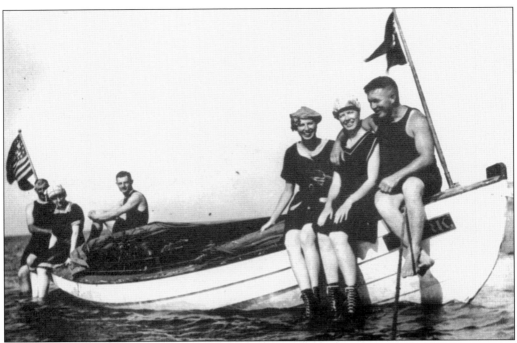

Anchored off the beach of Coatue, the *Spark* provides a lively source of entertainment for a group on a beautiful Nantucket day. Featured in this photograph are, from left to right, boat owner Willard Bunker Marden, Annie Greyer Marden, Edward Romeo Butler, Marie Marden Coffin, Erla Marden Butler, and Leo Thurston. (P22464, photographer unknown.)

Historically, Nantucket has been home to diverse communities, both year-round and seasonal. Many communities, such as the Cape Verdean, count their ancestors as having lived here for a long time. This photograph includes Isabel Barrows, Frankie White, and Jean Montaro Wall. (SC72, photographer unknown.)

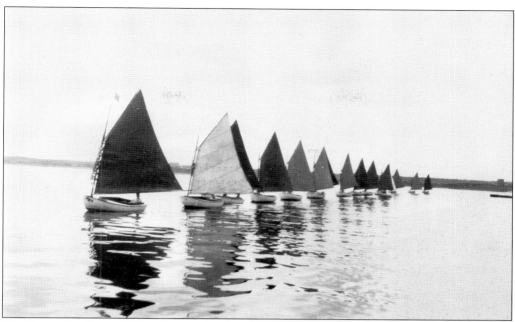

The Nantucket Yacht Club's addition of multicolored sails on 12-foot-4-inch Beetle catboats in 1925 created the Rainbow Fleet. Today, the Rainbow Fleet leads the sailboats out of the harbor for the start of the Opera House Cup during Nantucket Race Week. (PH6-2-7, photographer unknown.)

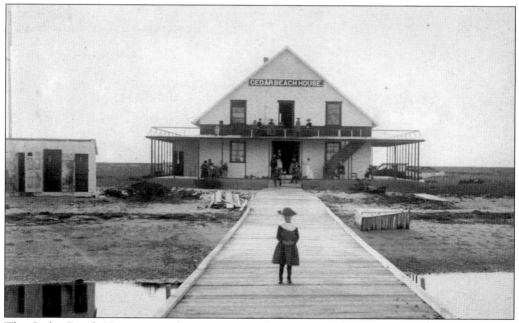

The Cedar Beach House opened on Coatue in 1883; passenger service from town was provided on the steam yacht *Coskata*. After 1890, a toboggan slide, swings, and other entertainments were offered. After it was closed for several years, it burnt down in 1908. (P8153, photograph by Josiah Freeman.)

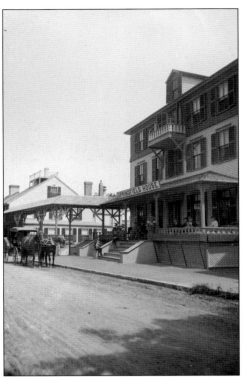

Several hotels were named variants of the Springfield House. The first was built at the corner of North Water and Chester Streets in 1836 and became the Springfield House in 1876. It was expanded and added an annex where there were billiards and a large dining room. This photograph shows the New Springfield House. (GPN2674, photographer unknown.)

The Sherburne House at 30 Orange Street was built in 1831. It has been a hotel at least since 1846, as the third Mansion House, the Adams House, and then the Sherburne House in 1873. In 1902, it became a private residence. (P5481, photographer unknown.)

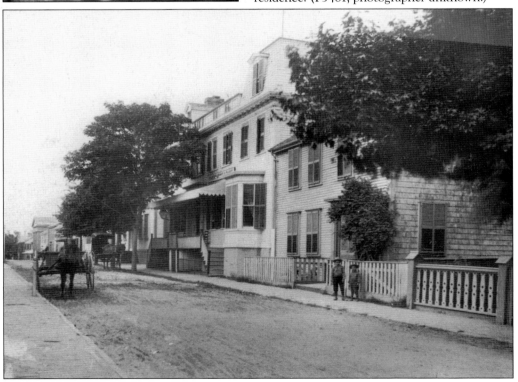

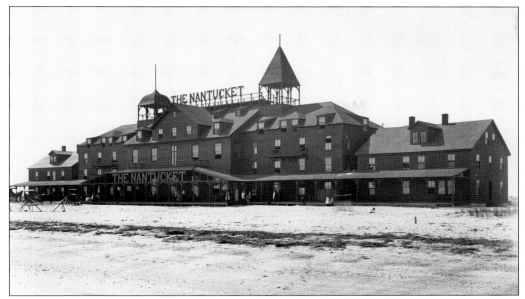

Nantucket Hotel, which opened in 1884, was of unprecedented size for Nantucket, taking up 200 feet along the beach on Brant Point. The main part of the building was originally the old Friends Meeting House on Main Street, subsequently used as a straw-hat factory, and then Atlantic Hall as a roller-skating rink. After the hotel was sold at auction in 1905, it was floated across the harbor to eventually become part of the Dreamland Theatre. (GPN2658, photographer unknown.)

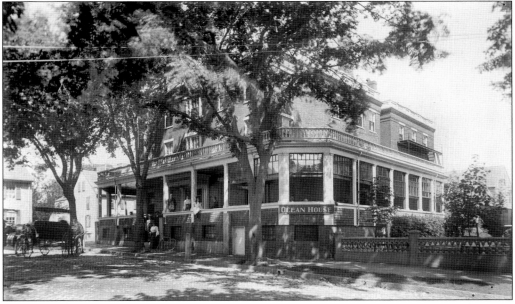

The Ocean House, now called the Jared Coffin House, is at the corner of Broad and Centre Streets. The present brick building was constructed by Jared Coffin in 1845. In 1847, the Nantucket Steamboat Company opened the Ocean House. The property changed hands several times, continuing as the Ocean House until 1961, when it was purchased by the Nantucket Historical Trust for restoration. (GPN2663, photographer unknown.)

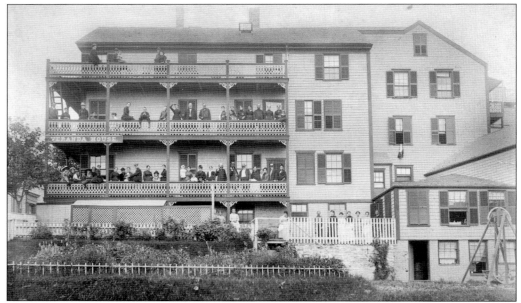

The Veranda House was built on the site of the 1684 house of William Gayer. Nathan Chapman and his wife purchased the building in 1881, and soon after, they opened their home to Coffin reunion attendees. Over the years, they expanded the building, purchased adjoining land, and moved the building to the corner to provide a view for their guests. The newly remodeled Veranda House continues to welcome guests. (P21296, photograph by Henry S. Wyer.)

The Atlantic House Hotel was the first building constructed as a hotel in Siasconset. It opened on Main Street in 1848 and operated until the 1910s. The hotel offered theatrical performances and musical evenings. (P14166, photograph by Alanson S. Barney.)

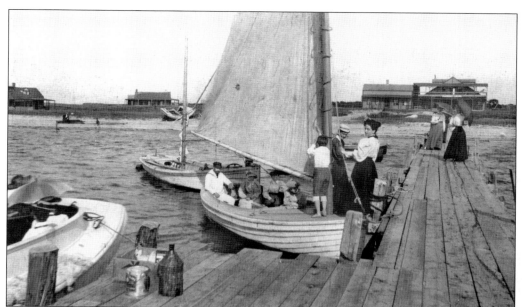

The Sharp family is pictured here at the Wauwinet dock. The Wauwinet House was established in 1876. It was named after a chief, or sachem, of the local Wampanoag tribe. The ground floor of the hotel had walls that could be folded back to catch the breezes. The Wauwinet is still in operation today, owned by New England Development. (P9611, photograph by Henry S. Wyer.)

The yachts *Lillian* and *Siren* provided transportation to the Wauwinet House directly from Steamboat Wharf. The steam-powered *Island Belle*, built by Capt. William Codd in his backyard on Orange Street, also provided this service. (GPN3149, photographer unknown.)

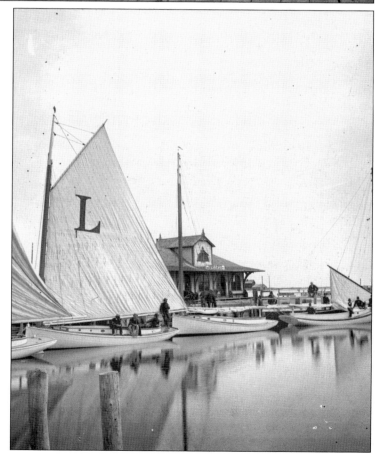

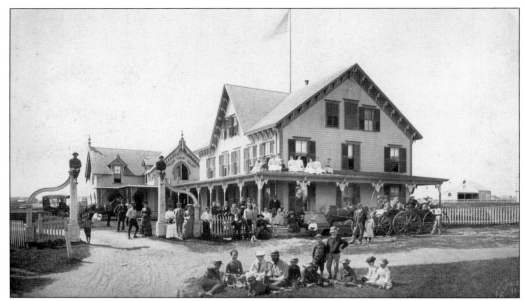

The Ocean View House in Siasconset opened in 1873. It featured a fruit and candy store. Later, buildings were added to accommodate more guests. The hotel closed about the time of World War I, as the focus of tourist interest re-centered back to the town of Nantucket. (P3092, photograph by Baldwin Coolidge.)

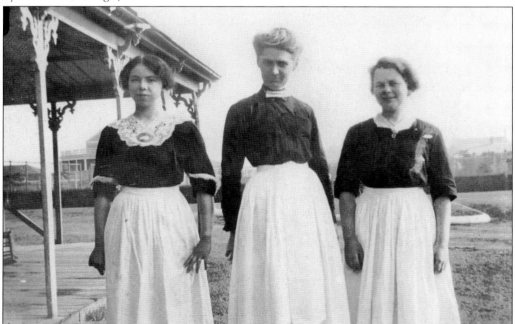

Many locals were employed by the hotels and other businesses catering to tourists and summer residents, many of whom were wealthy and returned every year. In Siasconset, the local community often lived downbank in Codfish Park; however, there were often rental cottages available for those who worked upbank. These young women worked at the Ocean View House in about 1908. (SC689-14, photographer unknown.)

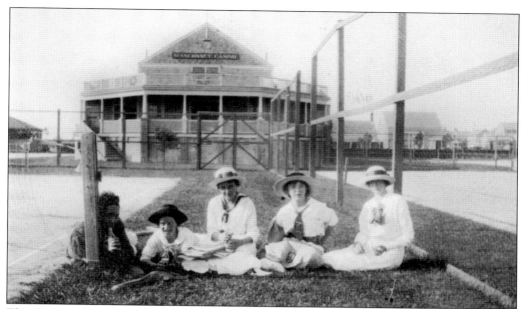

The 'Sconset Casino was built in 1900, when the summer residents grew tired of crowding into the railroad depot to put on theatrical performances. It provided a stage, a place for dances, to play tennis, or just to play cards. It still operates as a private club, offering many events open to the public. (P20865, photographer unknown.)

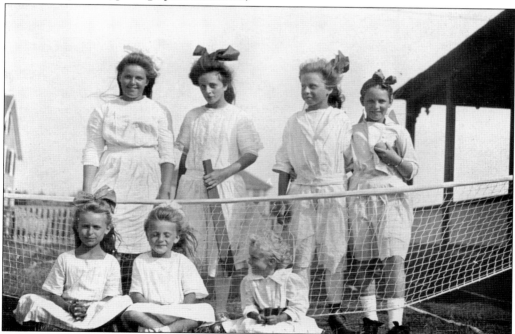

Nantucket was known as a healthy resort, with plenty of wholesome exercise activities available. These girls have been playing lawn tennis at 'Sconset Casino around 1900. From left to right are (first row) Virginia Tobey, Billy Doyle, and an unknown friend; (second row) Adrienne Pope, Mary Doyle, Enid Doyle, and Linda Lee Wallace. (P12595, photographer unknown.)

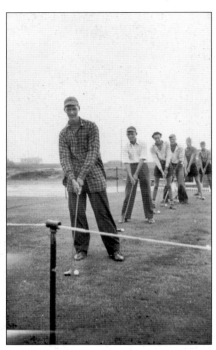

Sankaty Head Golf Club, the island's second golf course, was first organized in 1898. It was abandoned and then firmly reestablished in 1923. Camp Sankaty, a camp for training caddies, was organized in 1930, and in 2010, the camp celebrated its 80th anniversary. In this 1941 image, caddies are practicing golf shots. (A28-16a, photographer unknown.)

The 'Sconset School of Opinion was established in an old livery stable on School Street in Siasconset by Frederic C. Howe, an economist and political reformer. Over the approximate 10 years of its existence, Howe brought many celebrities, academics, and others to 'Sconset to participate in a lecture series and think tank. (F1730, photographer unknown.)

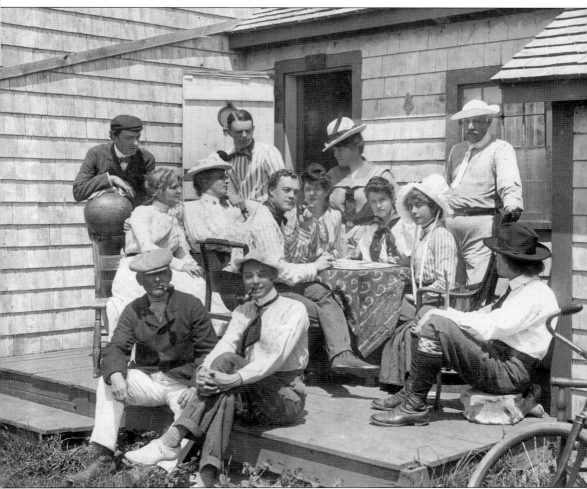

Siasconset became a haven for many of Broadway's most famous actors in the late 19th and early 20th centuries. They rented or owned rustic cottages or stayed with friends or at the Ocean View House hotel. This 1903 photograph shows Harry Woodruff in the center and also includes Nanette Comstock, Mary Shaw, Laura Joyce Bell, Charles Henry Meltzer, Robert McKay, Frank Perry, Frank Burbeck, and Walter Hale. As moving pictures gained popularity, many actors moved to the West Coast; Broadway and Nantucket lost many of its famous actors. However, the culture of theater remains strong here. Several local theater companies have grown, both small and large. The Fawcett Players, established in the 1920s by Margaret Fawcett, daughter of Percy Haswell and silent-screen star George Fawcett, changed its name to Theatre Workshop in 1955 and continues to offer year-round performances. (PH53-69, photographer unknown.)

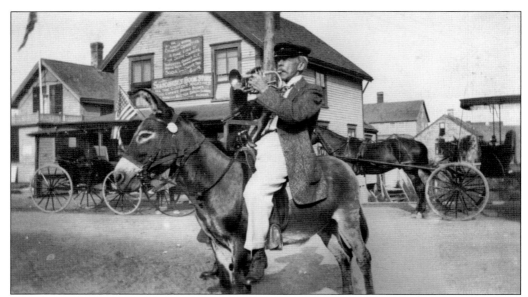

Doc Powers, owner of the Ocean View Hotel, would greet guests of his hotel as they arrived on the train by blowing his bugle while riding a donkey. A similar performance would be presented upon the visitors' departure. (P2819, photographer unknown.)

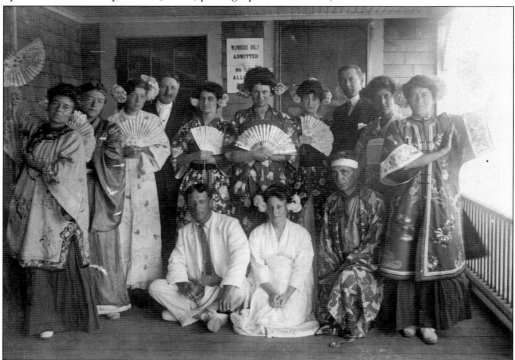

Many of the summer residents of Siasconset gave amateur theatrical performances. This photograph shows performers in costumes prepared for an Asian-themed play at 'Sconset Casino. Before the casino was built, shows took place in the railroad depot or the Atlantic House Hotel. (SC870-2, photographer unknown.)

Edward Underhill was a summer resident in Siasconset who had prospered through his work as a court stenographer. In the mid-1880s, he bought property on the south side of Siasconset and built little cottages modeled after fishing shacks. This photograph features 1 Evelyn Street. (GPN4028, photographer unknown.)

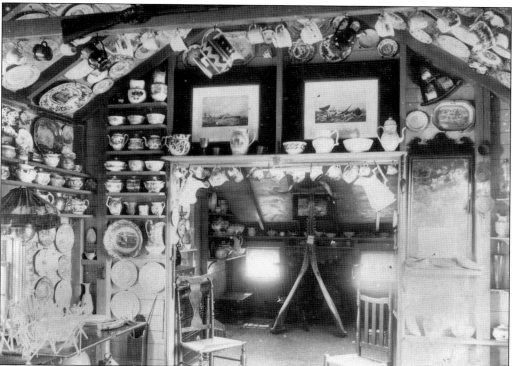

The China Closet was Edward and Evelyn Underhill's summer residence. It housed their extensive collection of china, acquired through their world travels. After Edward died, Evelyn gave a home to a young African American woman and her child, Florence Higginbotham. When Evelyn was in her 80s and had lost her fortune, the tables turned with Florence giving Evelyn and her china a home at her house at 27 York Street. (P9255, photographer unknown.)

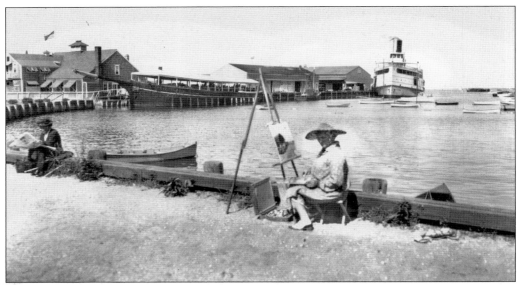

During the time between the two world wars, Nantucket developed as an artist colony. Florence Lang rented the small shacks on the wharves as studio spaces, available for very low rent. In the background is Steamboat Wharf and the Skipper Restaurant. (F1929, photographer unknown.)

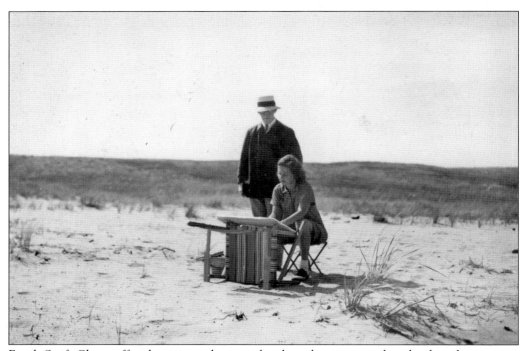

Frank Swift Chase offered painting classes to locals and visitors on the island in the summer. Many of the classes were en plein air, helping to create the feel of Nantucket as a tranquil artistic community. (A97-47c, photographer unknown.)

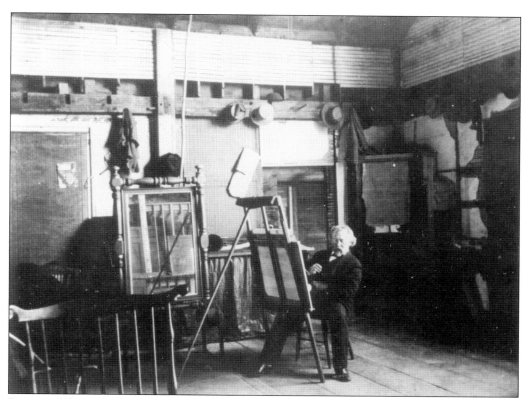

Eastman Johnson was a prominent painter in America during the late 19th century. He was a cofounder of the Metropolitan Museum of Art in New York City, and his portraits of the wealthy and influential can be found in many museums. Johnson also painted scenes of everyday life and the common workman. Included in these are several depictions of Nantucket. His painting *The Cranberry Harvest, Island of Nantucket* (1880) is considered to be one of his greatest works. In this photograph, he is seated at the easel, working in his studio on Cliff Road. (P15222, photograph by Henry Platt.)

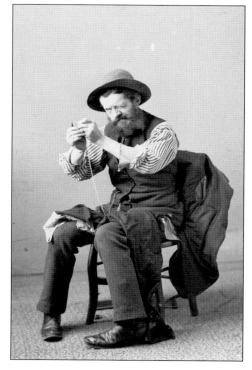

James Walter Folger, born in 1851, learned woodcarving in Cambridge, Massachusetts. When all his tools were lost in a fire, he returned to Nantucket to carve and paint on wood. He entered many of his artworks in the local agricultural fairs. Although his art was successful, he was little interested in financial affairs and died in poverty. This photograph is probably a study for his painting *Uncle Asa Mends His Trousers*. (GPN4451, photographer unknown.)

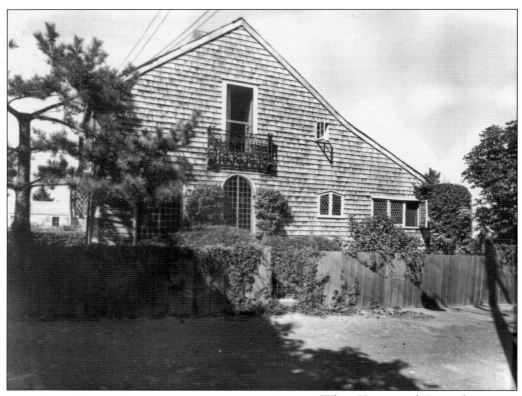

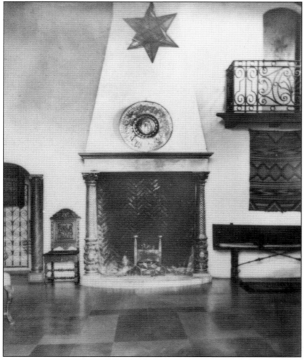

When Hanna and Gertrude Monaghan followed a herd of cows to a barn on Howard Street in 1929, they were inspired to create a home that was a work of art. They collected items from around the world based on their Quaker philosophy of divine interior light. The property was bequeathed to the Nantucket Historical Association in the 1970s and extensively renovated in 2011. (P20096, photographer unknown.)

The stucco fireplace of the great room of Greater Light was large and eye-catching, with gold pillars on either side. The transformation from a livestock barn to visionary household included the removal of 17 loads of manure. (P20099, photographer unknown.)

The patio and garden of Greater Light was an essential part of their vision. Large iron gates that they had rescued from a junkyard years before they purchased this barn fit perfectly in their new garden. They added a tall board fence along the street to assist in protection from prying eyes. Many of the locals, according to Hanna, reacted to the project as if the circus was in town. (PH37-7, photographer unknown.)

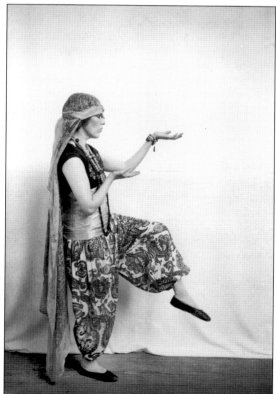

The two sisters hosted evenings of amateur dramatics. Here, Hanna Monaghan poses in harem pants. The Nantucket Historical Association acquired the property in 1970. After renovation in 2011, the property is now open to the public and used for theatrical performances, poetry readings, and other events that the Monaghan sisters would appreciate. (PH37-n60, photographer unknown.)

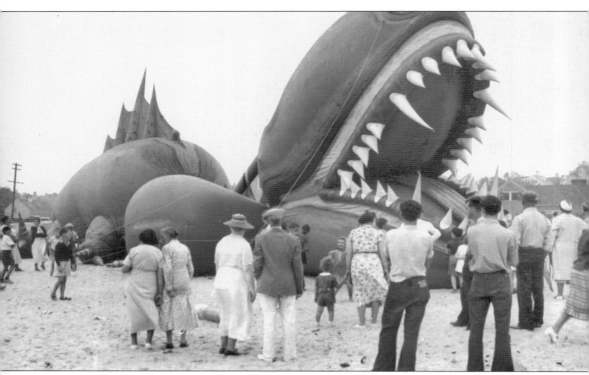

In the summer of 1937, Tony Sarg was at the forefront of a hoax on the people of Nantucket. For several weeks, sightings of a strange beast in the water were reported. People spread rumors. Photographs of men examining and measuring strange footprints on the beach were printed in the *Inquirer and Mirror*. What could it be? Then, one day in July, the sea serpent invaded. Tony Sarg and friends floated a giant sea serpent balloon designed by Sarg for Macy's Thanksgiving Day Parade from Coatue to land at South Beach on Washington Street. They were aiming for the Jetties, but apparently, the trajectory of floating giant semi-inflated balloons is difficult to control. The sea serpent was visited by tourists and natives alike. (PC-Humor-7, photograph by H. Marshall Gardiner.)

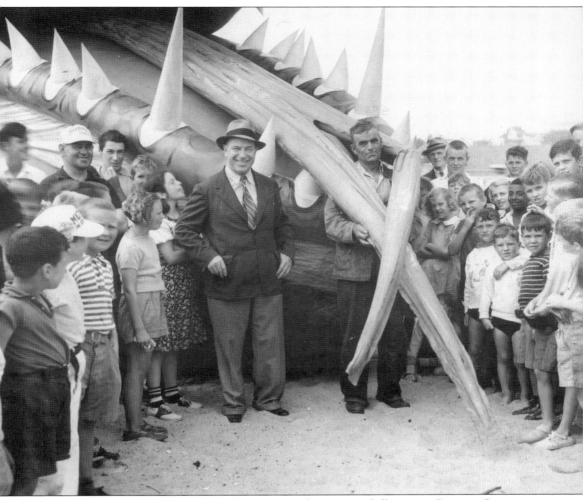

Tony Sarg (1880–1942) was a prominent puppeteer, designer, and illustrator. Born in Germany, he immigrated and married American Bertha Eleanor McGowan. Tony designed wallpapers, cards, jigsaw puzzles, and children's books; he illustrated advertisements, magazine covers, and books. He also decorated interiors of businesses including nightclubs and restaurants. He first gained prominence through his marionette theater. With Bill Baird, he designed and built giant balloons that were used in Macy's Thanksgiving Day Parade, which continues to be an American institution. In 1935, he did the first of his mechanically animated window displays for Macy's. A summer resident, he also owned a store on Nantucket, Tony Sarg's Curiosity Shop, at 38 Centre Street. A creative genius, Tony's fortunes took a downturn at the end of his life. Bankrupt, he died of complications from appendicitis at the age of 62. (P21725, photograph by Pivirotto.)

The increase in summer visitors allowed businesses to thrive during the season. Here, a fisherman walks past Sylvia's antiques shop on South Water Street, where visitors could always count on finding nautical souvenirs and curiosities, including a figurehead from a ship, a harpoon, and scrimshawed canes. (F2312, photograph by Louis S. Davidson.)

A group of six young riders on horses and an instructor pose on Main Street in front of H. Marshall Gardiner's Art Shop on Main Street in the 1930s. Gardiner's shop was open during the summer months for years. He used his photographs to create picturesque hand-colored postcards that were very popular in the first half of the 20th century. (P15452, photograph by H. Marshall Gardiner.)

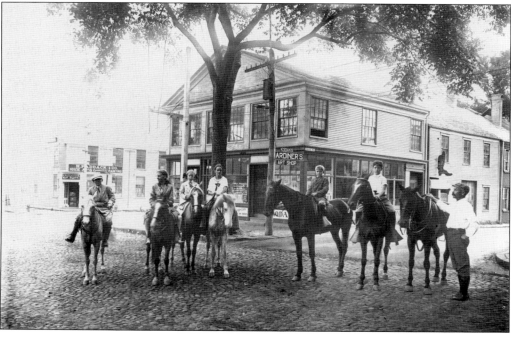

Five

A Changing Community
of Resilient Individuals

Nantucket is, and always has been, of its own time: forward thinking in its early embrace of the then-radical ideals of abolitionism, woman suffrage, and universal public education, yet ever mindful of its past and deeply conservative regarding change. The phrase one often hears is, "Well, that's not how we do things on Nantucket." This stubborn streak of egalitarianism salted with a heavy dose of skepticism for the new and improved has always drawn freethinkers, artists, and eccentrics to the island's shores, not to mention producing more than a few of its own.

Kezia Coffin, a controversial profiteer during the Revolutionary War, attained infamy in Joseph C. Hart's *Miriam Coffin*. In the late 1800s, Fred Parker, the "Hermit of Quidnet," became a figure of some curiosity to the new crowds of summer tourists, a hermit who enjoyed (or endured) a large number of visitors. Billy Clark, the best known of the town criers, would skim the newspapers coming off the steamships and race up Main Street, blowing his horn and announcing the latest news from the outside world. Perhaps the most famous son of Nantucket combined all three categories in one remarkable person: although Benjamin Franklin was born in Boston, his mother was a Nantucketer, and he famously quipped that although he was launched in that great city, his keel was laid in Nantucket.

Nantucket native Lucretia Coffin Mott, an early leader in the abolitionist and women's suffrage movements, worked closely with William Lloyd Garrison and Elizabeth Cady Stanton. Garrison brought Frederick Douglass to Nantucket, and Douglass gave his first public address to a mixed race audience there at the yearly convention of the Massachusetts Anti-slavery Society. Phebe Coffin Hanaford was a Universalist minister, confederate of Stanton and Susan B. Anthony, and an essayist of some renown. Cyrus Peirce, the educational pioneer, married a local Coffin and became the first principal of Nantucket High School. One of his pupils, Maria Mitchell, went on to become an educator at Vassar College and an astronomer who discovered a comet, for which she was awarded a medal by the king of Denmark.

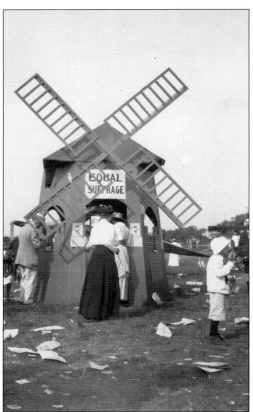

With a history of strong women starting with Petticoat Row, female-owned businesses along Centre Street during the whaling era, Nantucket was an island where there was much sympathy for women's rights and suffrage. This booth was located at a fair in the 1910s. (P6610, photographer unknown.)

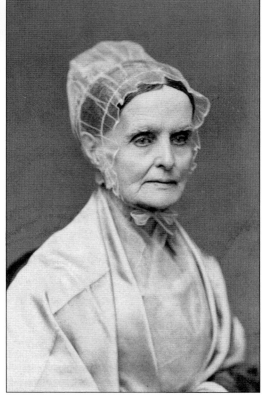

Lucretia Mott was born Lucretia Coffin on Nantucket in 1793. She was born into a Quaker family and became a Quaker minister in 1821. Mott wrote and spoke widely on women's rights and antislavery throughout her lifetime. (CDV1327, photograph by F. Gutekunst.)

Another prominent Nantucket feminist and antislavery advocate was Phebe Coffin Hanaford. Born in Siasconset to Quakers descended from the island's settlers, Hanaford embarked on a career writing and speaking against slavery and for women's rights. (P14374, photographer unknown.)

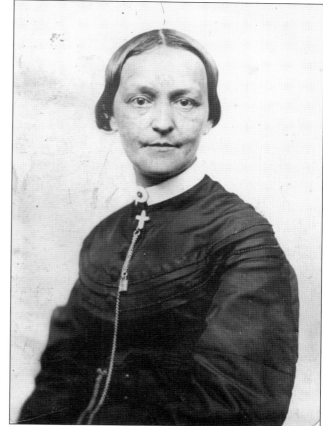

Young women in Nantucket during the 1880s formed many clubs that raised funds for charitable purposes. This image shows the Octagon Club, eight girls whose motto was, "To give is to live, to deny is to die." (PH38-75, photograph by Josiah Freeman.)

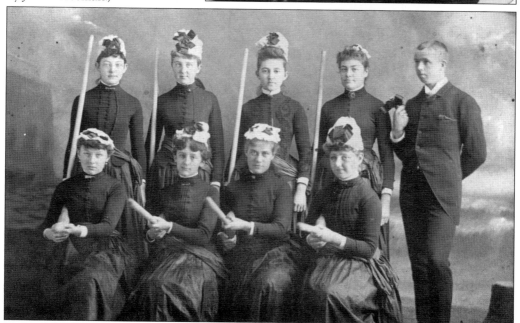

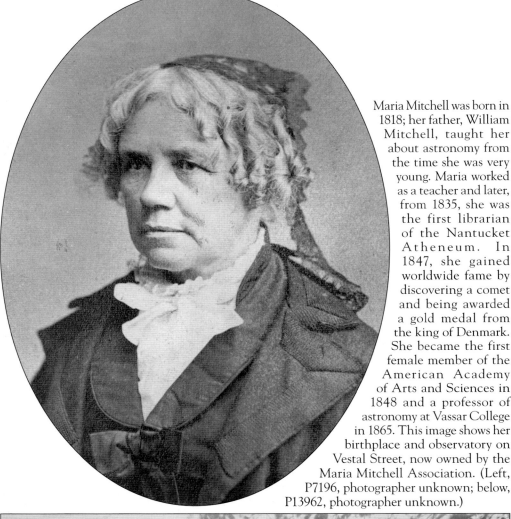

Maria Mitchell was born in 1818; her father, William Mitchell, taught her about astronomy from the time she was very young. Maria worked as a teacher and later, from 1835, she was the first librarian of the Nantucket Atheneum. In 1847, she gained worldwide fame by discovering a comet and being awarded a gold medal from the king of Denmark. She became the first female member of the American Academy of Arts and Sciences in 1848 and a professor of astronomy at Vassar College in 1865. This image shows her birthplace and observatory on Vestal Street, now owned by the Maria Mitchell Association. (Left, P7196, photographer unknown; below, P13962, photographer unknown.)

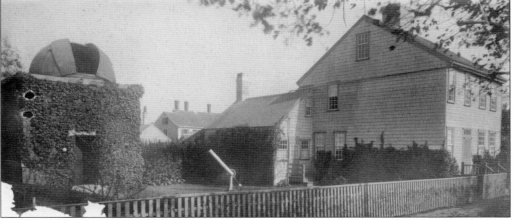

William Baxter, pictured here with some of his collections, offered taxi service and delivered the mail to 'Sconset to his house Shanunga, which he also referred to as the post office. The story is that when the government heard about this illegal post office, it sent someone to investigate. Baxter took the inspector to Polpis instead of Siasconset, leaving the inspector to believe that the story of the illegal post office was not true. (P127A, photograph by Henry S. Wyer.)

Capt. Zeb Tilton was master of the *Alice Wentworth*, which shipped cargo along the Eastern Seaboard. He was a large, cross-eyed man with large hands; he and his ship were known in every port from Maine to New York. In the late 1930s, when the business of shipping was no longer profitable, a group of supporters bought the boat and set Zeb up as captain until he could no longer sail. (A95-6, photograph by Stanley E. Roy.)

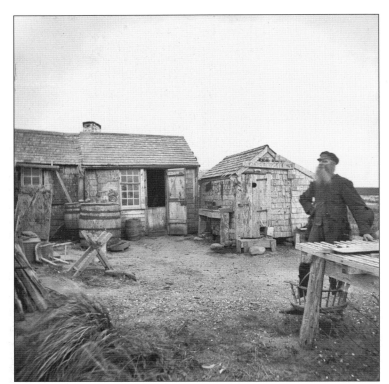

Frederick J. Parker, a carpenter, moved to a small shack in Quidnet shortly before the Civil War, decorating it with quarterboards from shipwrecks. During the 1870s, no visit to Nantucket was complete without a tour of the island, including a visit to the hermit of Quidnet. (GPN-shute-1, photograph by Charles H. Shute & Son.)

The U.S. Coast Guard awarded Mildred "Madaket Millie" Jewett the highest honorary civilian rank possible: chief warrant officer W-4. Her gruff demeanor and dedication to animals was legendary. Her ice cream shop was a frequent stop for Madaket children. (P7654, photograph by Beverly Hall.)

Conspicuous in Nantucket during the late 19th century was Billy Clark, the town crier. Blowing his tin horn, he would roam the town, shouting alerts of boat arrivals, newspaper headlines, and what products were for sale at local businesses. (GPN3633, photograph by Henry S. Wyer.)

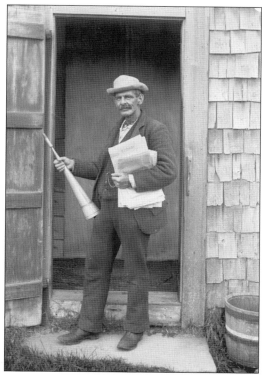

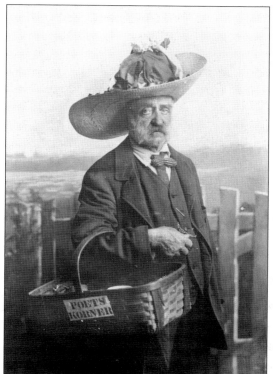

Elisha Pope Fearing Gardner (died 1913), poet and peanut vendor, lived in a small house called Poet's Korner. Amid exhibitions of relics of whaling days were signs, verses, and advertisements for his "boneless peanuts." Reportedly a Union spy during the Civil War, he was a man of many talents, especially self-promotion. His little house and poetry were featured in many writings about Nantucket in the late 19th and early 20th centuries. (F5396, photographer unknown.)

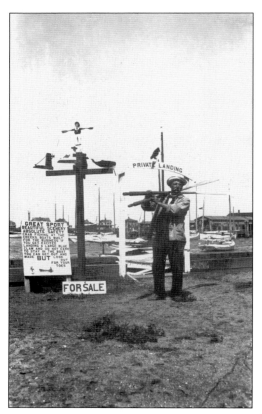

William H. Chase had a shop on Old North Wharf, where he sold his hand-carved whirligigs. A sign near him offers boats for crab fishing. Customers are told they may exit the boat and wade but to "watch out for their toes." (F6689, photographer unknown.)

William Sturgis Bigelow (1850–1926), physician, Buddhist philosopher, photographer, esteemed collector of Japanese art, and friend to Theodore Roosevelt, built a large house and dock on the west end of Tuckernuck in the early 1880s. Visitors, only men, talked philosophy in their pajamas or in the nude; all guests were required to don formal dress for dinner. Bigelow later donated over 40,000 objects to the Museum of Fine Arts in Boston, helping to found the Department of the Art of Asia there. His house, after being moved from the shoreline in 1926, finally fell to erosion in 1941. (P6636, photograph by Charles A. Hoyle.)

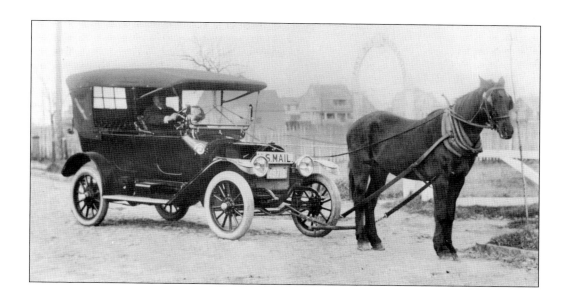

For nearly 20 years, from 1900 to 1918, Nantucket was the only town in the nation that successfully fought encroachment of the automobile. Opposing politicians on the mainland and large property owners, mostly nonresidents, Nantucketers kept the island free of the gasoline buggy until the final vote of the town on May 15, 1918. By the narrow margin of 40 votes—326 to 286—the automobile was allowed entry. Clinton Folger was the mail carrier for Nantucket. Because cars were forbidden in the town, he towed his car, commonly referred to as the "Horsemobile," to the state highway for driving to Siasconset. Pictured below are two Nantucket officials, Joseph Terry and Orison Hull, posting a notice on Steamboat Wharf that reads, "Motor Vehicles are Excluded From This Street. 1913 November 2." (Above, P14797, photographer unknown; below, F6531, photographer unknown.)

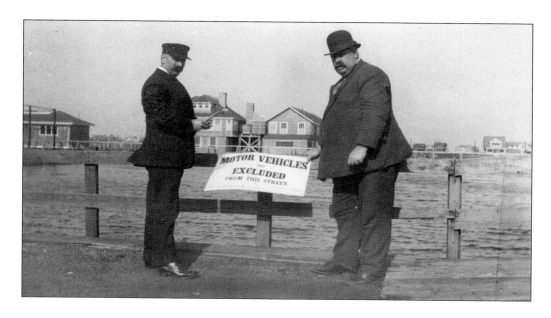

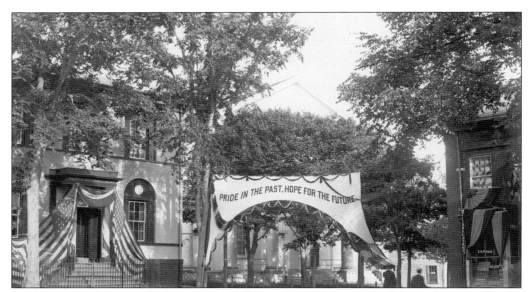

In 1895, Nantucket hosted a centennial celebration. In 1795, the town of Nantucket was officially incorporated, changing its name from Sherburne. There was a parade featuring many floats, and every house was decorated with bunting. Several large banners stretched across roads coming into Main Street Square. This sign reads, "Pride In The Past, Hope For The Future." (GPN2591, photograph by Henry S .Wyer.)

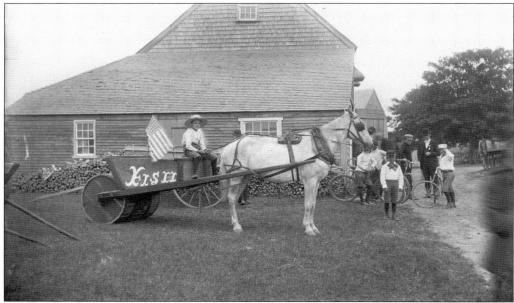

A traditional cart, often seen in Siasconset, was the fishing dray, which used a barrel as wheels. This cart (and the boy) were outfitted to be part of the 1895 centennial celebration. In the background is the Richard Gardner house (139 Main Street), built in the late 17th century. (GPN2600, photograph by Henry S. Wyer.)

Many neighborhoods had a "cent school," where young children learned academic basics, with each child paying a penny per day. Cent schools also offered nursery care periodically through the week. This is the Hepsibeth Hussey School on Fair Street, located at the corner of Charter Street. (GPN437, photograph by Josiah Freeman.)

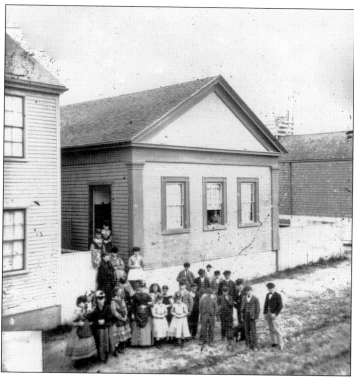

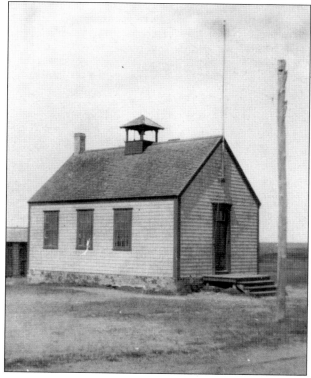

The Polpis School was one of several schools in the Nantucket system. Other outlying areas with their own schools included Madaket, Siasconset, and Tuckernuck. As population patterns changed and travel was easier, these smaller schools closed in favor of centralized schooling. (P21993, photographer unknown.)

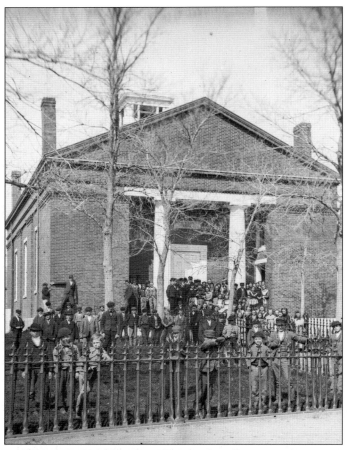

The first Coffin School was established on Fair Street by Adm. Sir Isaac Coffin in 1827. The building, located at 4 Winter Street, was erected in 1854. The school emphasized nautical skills and even featured a brig, the *Clio*, which boys sailed all the way to Brazil. The school closed in 1898 and reopened in 1903 with an emphasis on vocational training, including home economics, carpentry, and metalwork. Handiwork was displayed at the end of each school year; shown below is a display of sewing. Nantucket's Coffin School was built on the Lancasterian model: older or more advanced students taught the younger ones. The advantage was that a large number of students could be taught basic or advanced skills at a low cost. (Left, PH18-26, photograph by C.H. Shute; below, GPN4309, photographer unknown.)

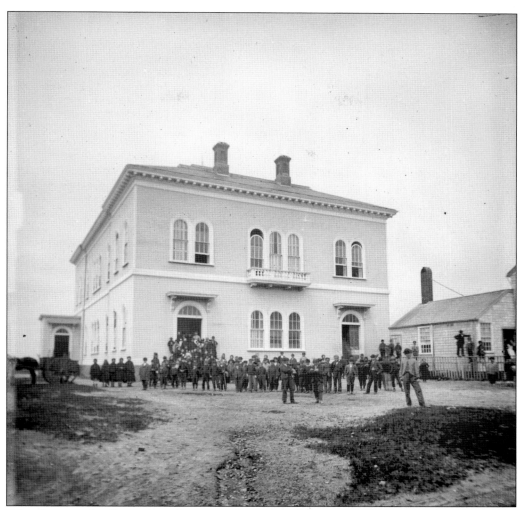

Schooling was chiefly conducted in private homes until the early 19th century, when the call for more formal public education was heard. It was the start of a long-term controversy in Nantucket, with the old guard of landowners not wanting to pay for the education of the children of the poorer families. Over the years, there were several grammar schools, including the North School, South School, West School, and Bear Street School (which changed its name to Spring Hill School in 1853). In 1863, the schools divided the town into the north and south districts, which remained the case for many years; there are many stories of the rivalry between the two. After 1838, the North School was located at the site of the present Academy Hill (pictured). The Academy Hill High School opened in 1856. This structure was replaced with a three-story, redbrick building in 1929. It now provides independent living for the elderly. (GPN-shute-28, photograph by Charles H. Shute & Son.)

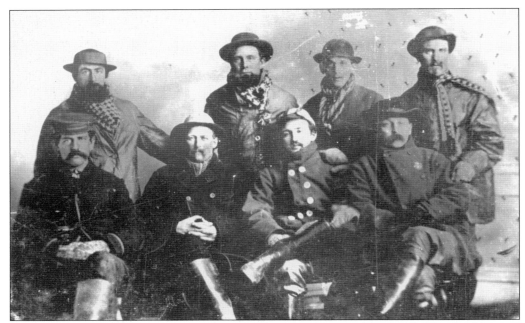

The Humane Society was formed in 1785 to render aid to victims of shipwreck. The first Humane Society station in Nantucket was built in Coskata in 1794. These huts of refuge were stocked with supplies to sustain shipwreck survivors. This photograph features the Humane Society boat crew of 1871. (P16951, photographer unknown.)

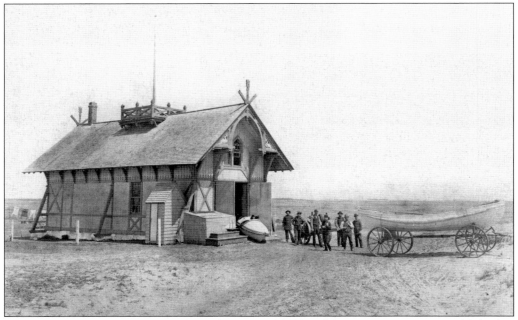

The US Life-Saving Service was formed in 1846. The first lifesaving station was established in Nantucket at Surfside in 1874. This view of the Surfside Life-Saving Station shows the life car, crew, and the lifesaving boat. The life car was an enclosed pod that, once filled with shipwreck victims, could be pulled to shore. (P4534, photograph by Josiah Freeman.)

The motto of the surfmen, who braved many a nor'easter in a 10-foot boat, was, "You have to go out, but you don't have to come back." This image features the crew of the Muskeget Life-Saving Station. Seen here are, from left to right, Capt. Albert Rohdin, Manuel Joseph, unidentified, Arthur P. Dunham, and Erastus Chapel. Sitting in the foreground is Annabel Martin. (P16265, photographer unknown.)

Swedish-born Albert Rohdin was keeper of the Muskeget Life-Saving Station until the Life-Saving Service merged with the US Revenue Cutter Service to form the US Coast Guard in 1915. He was then promoted and transferred to the Surfside station. (P16264, photographer unknown.)

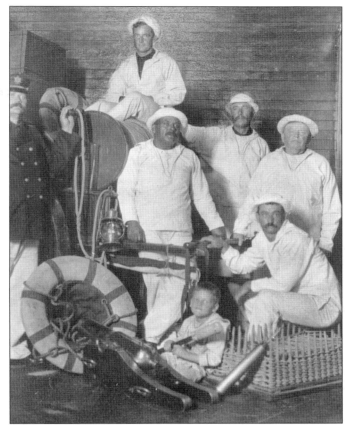

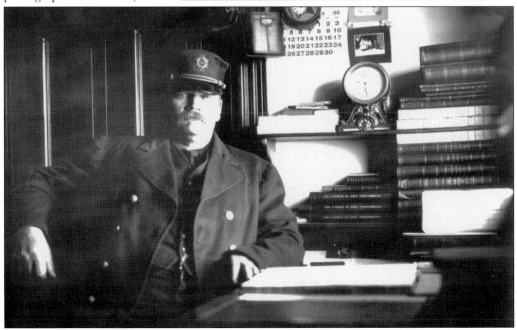

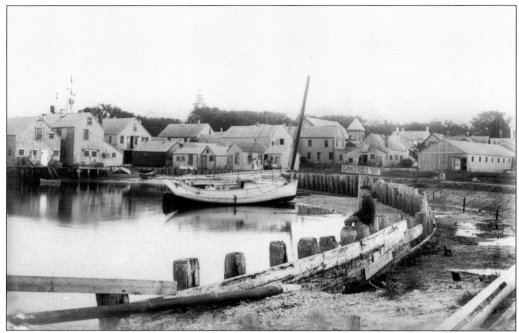

A young boy sits on a fence in the Easy Street boat basin, ignoring the sign above him that reads, "Dangerous, keep off." This area was filled in before the railroad was developed. It was originally a swampy open area. (P14951, photographer unknown.)

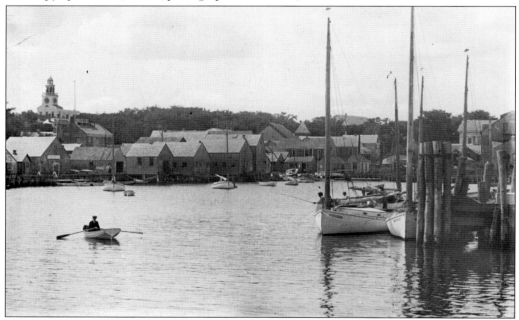

This photograph, showing men fishing from the catboat Wonoma, was taken long after the forest of masts that used to throng the harbor had faded away. Outbuildings suitable to the task still lined the wharves, but they now were empty, used for another purpose, or had crumbled in decay. (GPN3132, photographer unknown.)

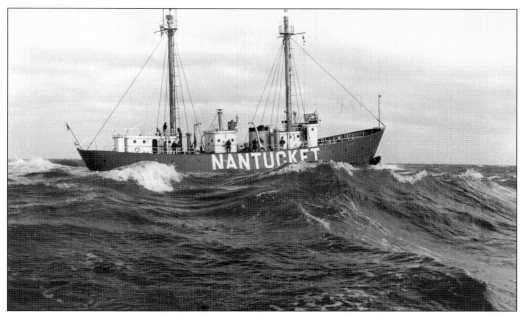

The lightship *Nantucket* marked the dangerous Nantucket shoals, south of the island. Lightships typically bore the name of the shoal they guarded. There were 11 lightships named *Nantucket*, each with its own identifying number. The crew lived onboard for weeks at a time; many people remember the ferry stopping to deliver mail to the boat at Cross Rip. The official use of lightships in the United States ended in 1985, when the US Coast Guard decommissioned the *Nantucket*. (F201, photographer unknown.)

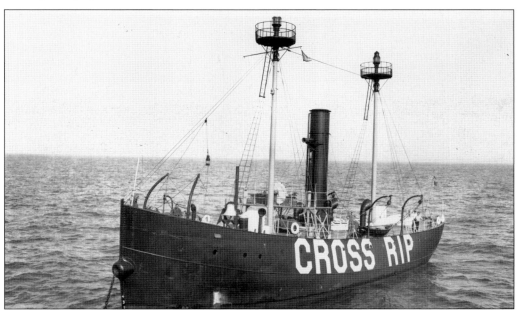

The lightship *Cross Rip* originally marked the shoal at Tuckernuck, then was moved in 1852 to the Cross Rip Shoal. The boat had several disasters. In 1918, it was blown from its mooring anchor; the ship and all hands were lost at sea. (P16269, photographer unknown.)

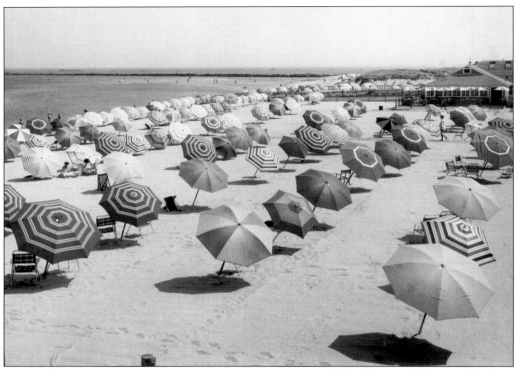

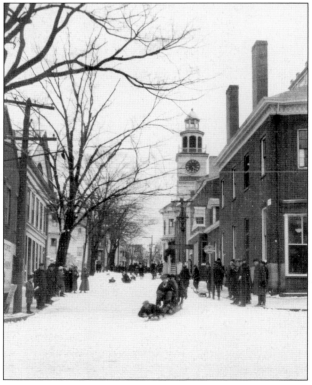

Cliffside Beach Club has offered a private beach since 1958. There is a public way just beyond the umbrellas where families often bring small children to play. Such easements are almost nonexistent on Martha's Vineyard, with the result that much of its beautiful shoreline is closed to the public; Nantucket is fortunate to have a number still in place and the opportunity to protect them for future generations. (P5837, photograph by Louis S. Davidson.)

When there was enough snow on Orange Street, the street closed for sledding. This image shows a group sledding in the 1910s at the intersection of Orange and Main Streets. The town clock on the Unitarian Universalist Church can be seen in the background. A similar scene can be viewed on snowy days in Nantucket today. (F6318, photographer unknown.)

Although Nantucket is famous as a summer holiday island, its maritime heritage continues. For many years, Straight Wharf was referred to as "Killen's Wharf" because it was the location of J. Killen and Company, which provided gasoline and lumber. (GPN3978, photographer unknown.)

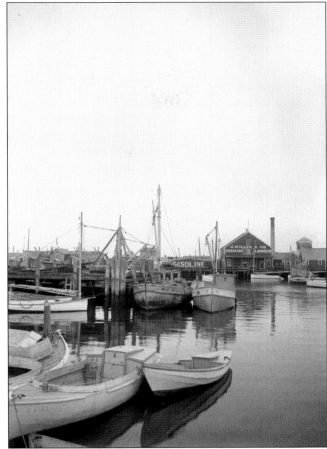

The *Martha's Vineyard* was built in 1871. Chiefly serving sister island Martha's Vineyard, a ship by that name has also been in service to Nantucket over the years. This steamship is cutting through the ice at Brant Point. (P16108, photographer unknown.)

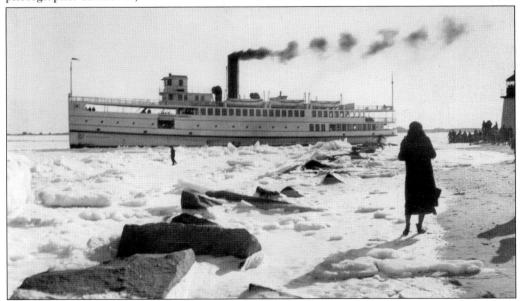

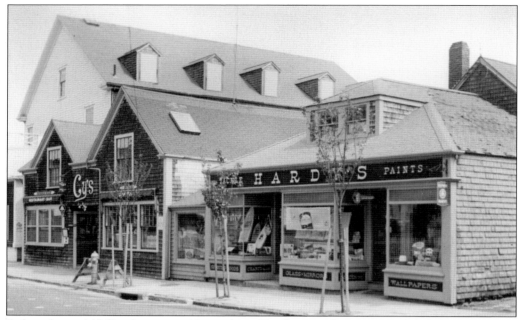

Before the mid-1960s, downtown Nantucket offered stores that supported daily life, including Hardy's hardware store and affordably priced restaurants like Cy's Green Coffee Pot and Restaurant on South Water Street, pictured here. The large building on the left is the Dreamland Theatre. (F6479, photographer unknown.)

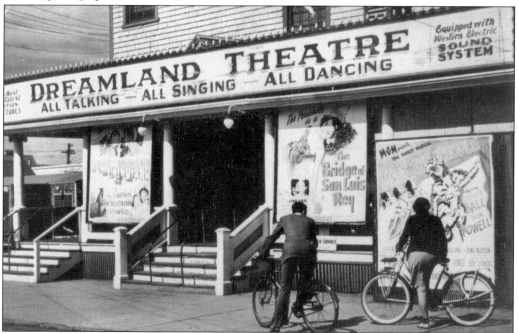

The Dreamland Theatre building was constructed from a section of the old Nantucket Hotel. Opening in 1911, the theater offered vaudeville for 20¢. Newly renovated in 2012, the Dreamland continues to offer entertainment and community space. (SC394, photographer unknown.)

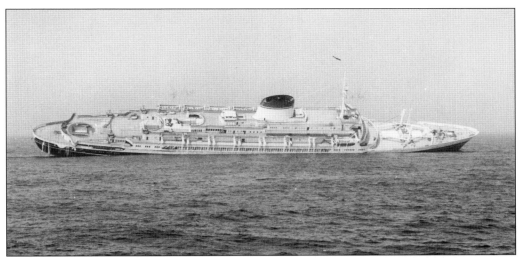

On July 25, 1956, the Italian liner *Andrea Doria* collided with the *Stockholm*. The *Andrea Doria* immediately began to sink. While 1,660 passengers and crew were rescued, 46 people died. Since the wreck, 16 divers seeking artifacts have died. (P12899, photograph by US Coast Guard.)

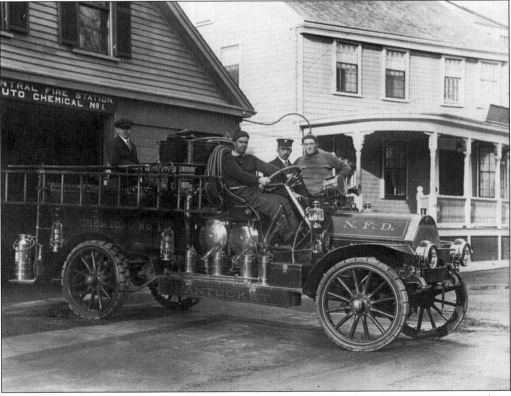

The Nantucket Fire Department's chemical fire engine was purchased in 1916. It is seen here in front of the station house on Centre Street. The building at right is the old Seven Seas Gift Shop with a decorative porch, since removed. That building is also notable as the home of Capt. George Pollard Jr. of the *Essex* disaster. (F4931, photograph by Maurice Boyer.)

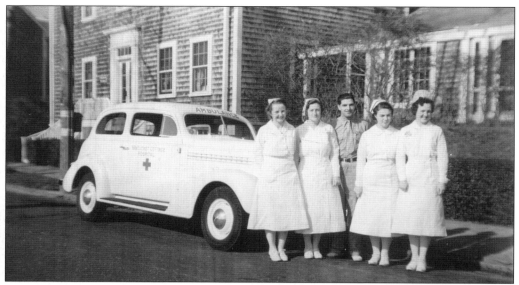

Nantucket Cottage Hospital was established at 23 West Chester Street in 1912. Originally, the hospital was open only in the summer season, but as the Nantucket population grew, a new 76-room hospital was established on Prospect Street in 1957. Posing here in front of the ambulance at the old hospital are, from left to right, Mary Faunce, Irene Chase, driver and orderly John Driscoll, and two unidentified nurses. (P13293, photographer unknown.)

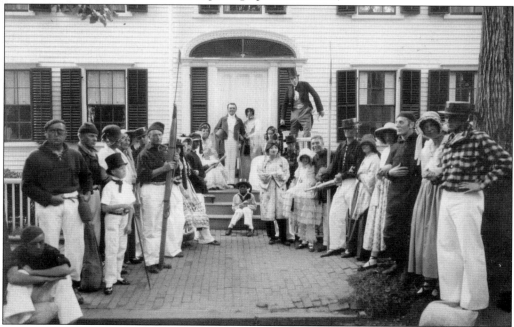

The first hospital fete was held in 1923. During this town-wide festival, many people donned period costumes, demonstrated traditional crafts, rode in amusing floats for a parade, and hosted tea and bake sales. Funds raised went to support the hospital. In this photograph, Austin Strong (with the top hat in his hand) poses in front of 99 Main Street surrounded by costumed friends. (P18145, photograph by H. Marshall Gardiner.)

In 1932, a young mechanic named David Raub and a farmer, Les Holmes, decided to plow up some cornfields and form the Nobadeer Flying Service, which provided charter service and instruction. Dave was also a significant participant in the Nantucket Flying Club, which featured acrobatic shows and parachute jumping, typically followed by hangar parties. He helped to organize Nantucket's first air show on August 6, 1939. In December 1943, Raub was killed during World War II while test flying a P-38. He taught many of Nantucket's early pilots to fly, including these young women, posing here in the summer of 1939. From left to right are (first row) Linda Loring and Doris Gilman; (second row) Jean Adams Cook (airport manager), Anne Beach, Grace Larkin Coffin, Edith Jenney, Kathryn Cady (married to Dave Raub), and Winifred Williams. (PH23-10, photographer unknown.)

The Wharf Rat Club congregates in its clubhouse on Old North Wharf. Attendance waxes and wanes as the thermometer varies. The club's motto is, "No Reserved Seats for the Mighty," and it is a place where people from all walks of life can meet with no regard to social status. From left to right are (first row, seated) Louis Davidson, George "Bunt" Mackay, Dick Deutsch, Flint Ranney, Pete Grant, and Harry Gordon; (second row, standing) Hugh Sanford and Charlie Sayle. The flag of the Wharf Rat Club was designed by artist and summer resident Tony Sarg (Above, P15588, photographer unknown; below, P1682, photograph by Louis S. Davidson.)

Walter Beinecke Jr., an heir to the S&H Green Stamp fortune, was instrumental in changing downtown Nantucket. After purchasing and developing much of the town's waterfront, Beinecke created a trust that poured millions of dollars into historic preservation. His goal of preventing the town from losing its character was largely achieved. (PH9-2-66, photograph by Beverly Hall.)

The grocery at Monument Square, located at 106 Main Street, was torn down despite the many regulations to preserve historic buildings on Nantucket. The Historic District Commission was established in 1955; in 1972, its authority was expanded to the entire island. This authority has been effective in preserving the island's historical character; but it has also come under intense criticism by residents who wish to develop their properties. (P15631, photographer unknown.)

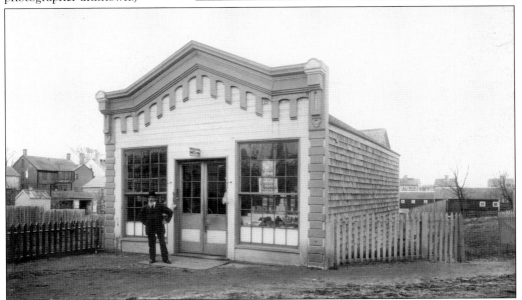

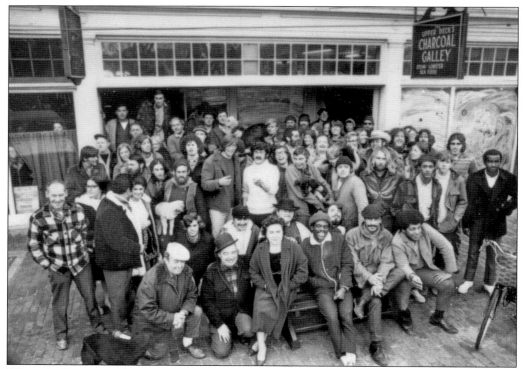

When the Bosun's Locker, a Main Street bar, closed on February 2, 1971, the loyal patrons gathered for a last photograph. To many, closure of this downtown, solidly working-class space marked a change in the feel of Nantucket's downtown. Today, this space is occupied by an art gallery. (F6046, photograph by Charles Folger.)

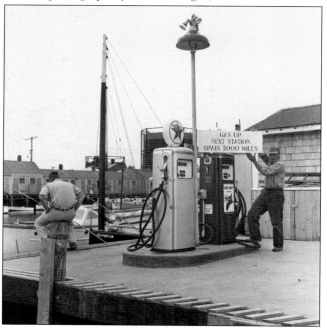

The Texaco station, formerly on Straight Wharf, displayed a warning sign: "Gas up, next station, Spain 3000 miles." Nantucket once had several gas stations—for boats and cars. Now there are four, and the price of gas vies with Hawaii as the most expensive in the country. (SC810-14, photographer unknown.)

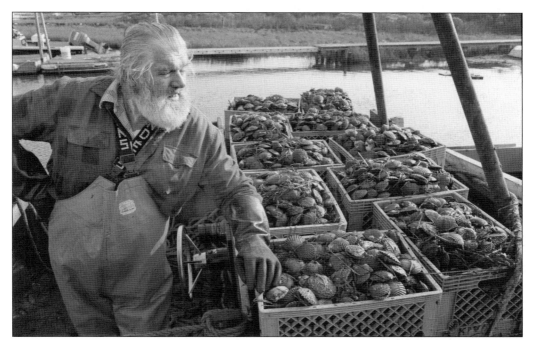

Scalloping continues to be a lucrative source of seasonal income for many Nantucketers. However, fertilizer runoff, other pollutants, and overfishing have endangered this traditional occupation, creating the need for more severe limits than were seen in previous years. In this 1990s photograph, Charlie Sayle examines his day's haul. (SC865-3, photograph by Rob Benchley.)

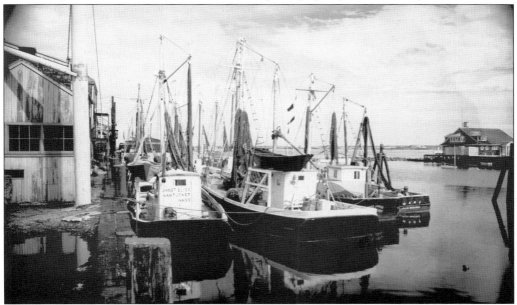

Nantucket was once the home of many commercial fishing draggers. Main Street was an active maritime economy until the late 1960s, with fish vendors on Main Street and workmen having an active presence. This photograph shows the fishing boat *Janet Elise* of Nantucket, *Mary* of New Bedford, and others docked at Old South Wharf. (GPN3974, photographer unknown.)

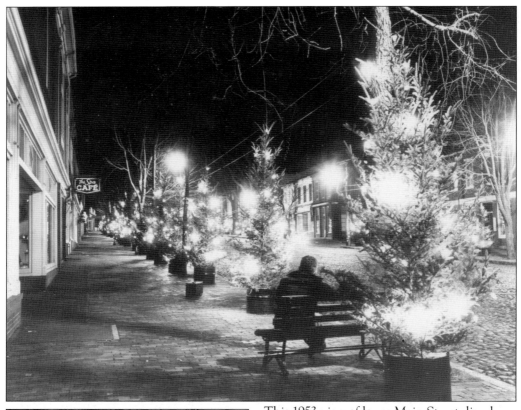

This 1953 view of lower Main Street, lined with lighted trees, is similar to what the street looks like today during the Christmas Stroll in early December through the winter holidays. Christmas Stroll weekend (the weekend after Thanksgiving) began in 1973 and includes trees decorated by island organizations, craft fairs, and carolers. (F5092, photograph by Dick Williams.)

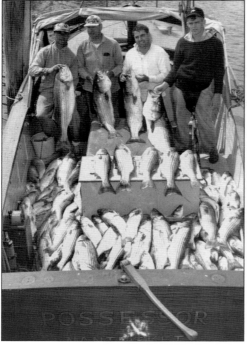

Sportfishing and the charter-boat business are now the most profitable commercial fishing enterprises. Four sportfishermen on the motor boat *Possessor* pose with their catch of the day, a boatload of striped bass. From left to right are Bob Francis, John Ewen, an unidentified man, and Paul Bennett. (SC386, photographer unknown.)

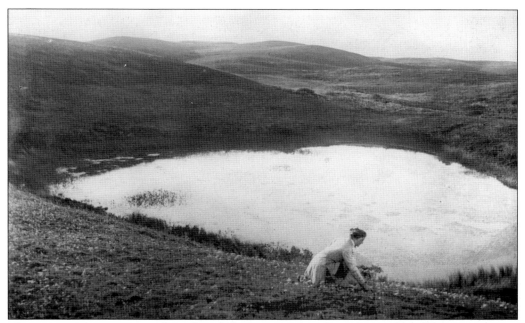

The scene of this woman picking flowers by Pout Pond in the 1890s could still be seen in parts of Nantucket. Approximately 45 percent of Nantucket is protected from development by private nonprofit organizations or government programs. This includes heathlands, dunes, bogs, and the rare habitat of sandplain grasslands. (GPN4356, photographer unknown.)

Being "native," a term used for someone born on the island, is a badge of pride for Nantuckers. In this photograph, taken in the summer of 2011, natives were invited to pose for a group photograph; young, old, black, white—all came to be seen and to see. Included in this photograph are coauthor James Grieder, his son and grandmother, and coauthor Georgen Charnes's daughter Cassia. (Photograph by Cary Hazlegrove.)

The Nantucket Historical Association's administrative offices and whaling museum on Broad Street were remodeled into a state-of-the-art exhibition facility in 2005. The organization has grown substantially since Mary Eliza Starbuck, in 1895, admonished Nantucket people to "make an active search for all sorts of relics, particularly manuscripts, before it is too late and these valuable mementos are carried away from the island as trophies, or by progressive housewives cast as rubbish to the void." (WM-2005-12, photograph by Vanderwerck.)

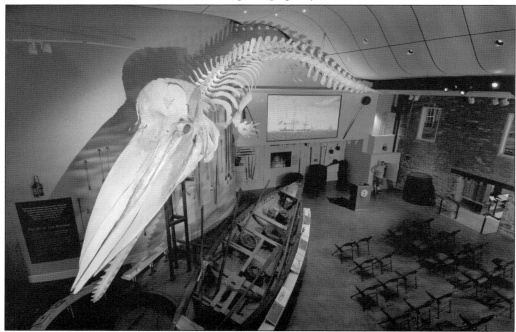

On January 1, 1998, a sperm whale became stranded on the 'Sconset beach. After biologists from the Woods Hole Oceanographic Institution had completed their investigations, the whale was dissected, using traditional whaling implements. The remains were submerged, and in 2003, the cleaned bones were articulated and a 46-foot skeleton was constructed. This behemoth is on display today in the whaling museum. (WM-2005-05, photograph by Vanderwerck.)

ABOUT THE NANTUCKET HISTORICAL SOCIETY

The mission of the Nantucket Historical Association (NHA) is to preserve and interpret the history of Nantucket Island and to foster appreciation of its historical significance. To that end, the organization has acquired historic properties, solicited donations of family papers and photographs, bought paintings and artifacts, and retrieved from rubbish bins materials thought to be of no use or historical interest.

The NHA was incorporated on July 9, 1894, after a small group of interested Nantucketers gathered together out of concern for the potential loss of historical materials, and the organization acquired the Quaker Meeting House at 7 Fair Street to use as its headquarters. Within a year, the NHA had accessioned 295 donations, including artifacts, photographs, and manuscript materials; there were also materials given on permanent loan, to be returned if the organization went under, which may have reflected a lack of confidence by the public. In the years since its organization, the NHA has more than satisfied the faith of those who entrusted it with their heirlooms. It has grown to hold more than 23 properties, more than 50,000 photographs, thousands more artifacts, and many collections of family papers. Moreover, it has offered interpretation of these items through public outreach programs, educational programs, public lectures, and publications.

The NHA has dedicated many staff hours and much of its capital to preserving the material brought into its collections—from the smallest hand-painted ivory miniature, to boxes of papers and photographs, to entire buildings. Collections are housed according to their preservation requirements and cataloged to provide ready access to researchers. The NHA Research Library, which houses all the materials presented in this volume, offers an excellent facility in which to work and provides stellar access to its collections through the databases (available online at www.nha.org).

Each historical item has its own tale to tell; but if an item is uncared for, that story is lost to us all. Please consider a few points when you are considering your family papers and photographs:

- Photographs, papers, and even artifacts are damaged by environments that feature changing levels of humidity. A good first step in preserving your family's treasures would be to remove them from the attic or basement.
- Take time to write identifications on your photographs, and make notes on letters of writers' last names. A note about the featured persons' relationships to others would also be useful, in case there are several family members with the same name.
- Store your materials in such a way that they won't be damaged. Archival-quality storage is available from most stores; beware of the damage from metal objects, such as paper clips and staples, and low-quality paper that can discolor adjacent items.

It is hoped that the images herein inspire the reader to learn more about Nantucket and its rich history and to appreciate the historical value of other aging materials that may be within your own reach.

BIBLIOGRAPHY

Claflin, James. *Lighthouses and Life Saving along the Massachusetts Coast*. Charleston, SC : Arcadia, 1998.

Gardner, Helen A. "Cent Schools." *Historic Nantucket* (Summer 1994, Vol. 43, No. 2)

Gardner, William E. "Nantucket Farms." *Proceedings of the Nantucket Historical Association* (1947).

Karttunen, Frances Ruley. "Dorcas Honorable: The Life and Heritage of an Oft-Married Woman." *Historic Nantucket* (Spring 2002, Vol. 51, No. 2).

———. "Living in the China Closet." *Historic Nantucket* (Fall 2002, Vol. 51, No. 4).

———. *The Other Islanders : People Who Pulled Nantucket's Oars*. New Bedford, Mass.: Spinner Publications, 2005.

Lancaster, Clay. *Holiday Island : The Pageant of Nantucket's Hostelries and Summer Life from Its Beginnings to the Mid-twentieth Century*. Nantucket : Nantucket Historical Association, 1993.

———. *Nantucket in the Nineteenth Century: 180 photographs and illustrations*. New York : Dover Publications, 1979.

Philbrick, Nathaniel. *Away Off Shore : Nantucket Island and Its People, 1602-1890*. Nantucket: Mill Hill Press, 1994.

Schmid, Peter. "The Nantucket Railroad." *Historic Nantucket* (Summer 2000, Vol 49, No. 3)

Tyler, Betsy. *Greater Light : A House History of Gertrude and Hanna Monaghan's Summer Home on Nantucket*. Nantucket : Nantucket Historical Association, 2010.

———. *'Sconset : A History*. Nantucket: Nantucket Historical Association, 2008.

———. *'Sconset Actors Colony: Broadway Offshore 1895-1925*. Nantucket: Nantucket Historical Association, 2011.

Young, Roger A. "Bicycles and Nantucket." *Historic Nantucket* (Spring 1992, Vol. 40, No. 1)

INDEX

DISCOVER THOUSANDS OF LOCAL HISTORY BOOKS
FEATURING MILLIONS OF VINTAGE IMAGES

Arcadia Publishing, the leading local history publisher in the United States, is committed to making history accessible and meaningful through publishing books that celebrate and preserve the heritage of America's people and places.

Find more books like this at
www.arcadiapublishing.com

Search for your hometown history, your old stomping grounds, and even your favorite sports team.